WASHINGTON, DC

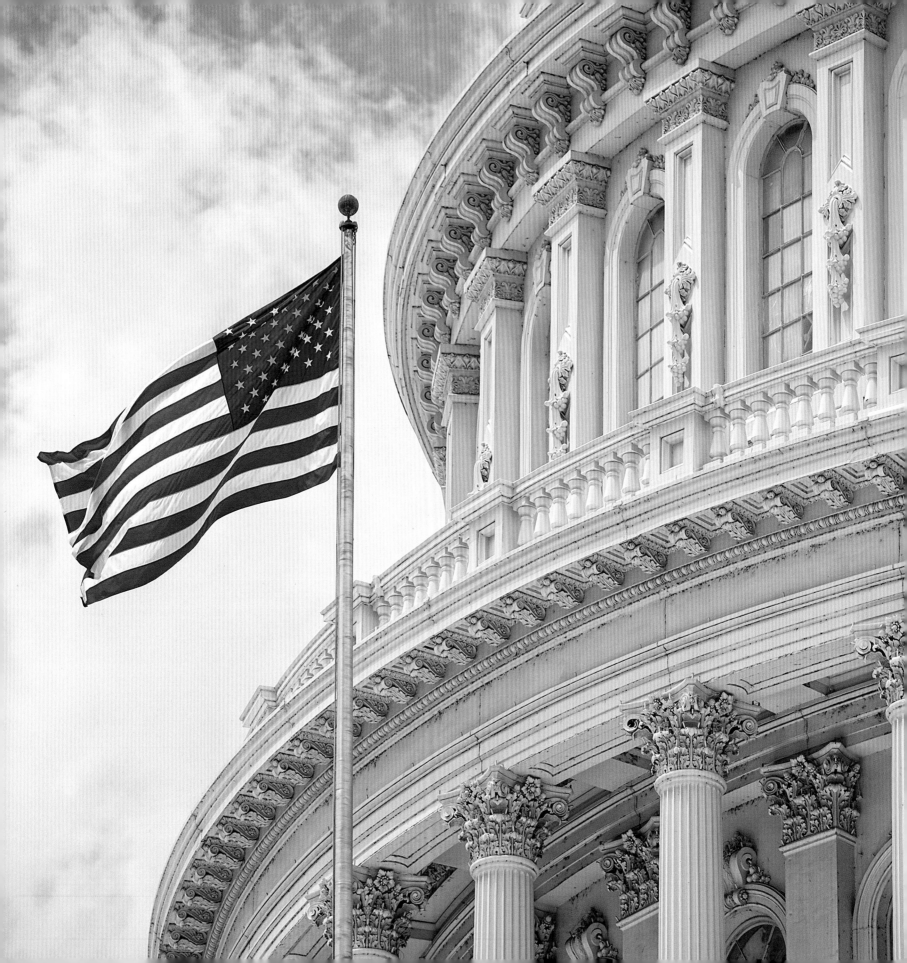

WASHINGTON, DC

THE NATION'S CAPITAL

Michael Worek

FIREFLY BOOKS

A FIREFLY BOOK

Published by Firefly Books Ltd. 2024
Copyright © 2024 Firefly Books Ltd.
Text copyright © 2024 Michael Worek
Photographs © as listed on page 110

Previous page: American flag flying outside the U.S. Capitol Building.

First printing

Library of Congress Control Number: 2024935773

Library and Archives Canada Cataloguing in Publication

Title: Washington, DC : the nation's capital / Michael Worek.
Names: Worek, Michael, author.
Identifiers: Canadiana 20240357523 | ISBN 9780228104810 (hardcover)
Subjects: LCSH: Washington (D.C.)—Pictorial works. | LCGFT: Photobooks.
Classification: LCC F194 .W67 2024 | DDC 975.30022/2—dc23

Published in Canada by
Firefly Books Ltd.
50 Staples Avenue, Unit 1
Richmond Hill, Ontario
L4B 0A7

Published in the United States by
Firefly Books (U.S.) Inc.
P.O. Box 1338, Ellicott Station
Buffalo, New York
14205

Cover and interior design: Jacqueline Hope Raynor

Printed in China | E

INTRODUCTION

Washington, DC, is not only the capital of the United States — it is a symbol of what makes America unique among the nations of the world.

In 1785 Congress voted to build a permanent federal city on the Potomac River, outside the boundaries of any state. George Washington selected French architect Pierre Charles L'Enfant to design the capital, with large ceremonial spaces and grand tree-lined avenues.

Since its creation Washington has become a city packed with history, full of monuments and memorials, iconic buildings, architectural landmarks, vibrant neighborhoods and outstanding museums.

Here is the White House — "a house owned by all the American people" — as well as the Capitol Building, the Washington Monument and the Lincoln and Jefferson Memorials. There are poignant scenes, too, including the eternal flame at JFK's gravesite, the memorial to Martin Luther King Jr. and the Vietnam Women's Memorial.

Other notable places include the Smithsonian National Museum of American History, the International Spy Museum, the National Gallery of Art, the Air and Space Museum, the National Museum of the American Indian, the John F. Kennedy Center for the Performing Arts and the National Museum of African American History, as well as Mount Vernon, George Washington's home in nearby Virginia.

Washington is a thriving city with a sense of history and grandeur that is unmatched anywhere else in the United States. Whether you're fortunate enough to live here or are just visiting, Washington, DC, has something for everyone.

WASHINGTON, DC

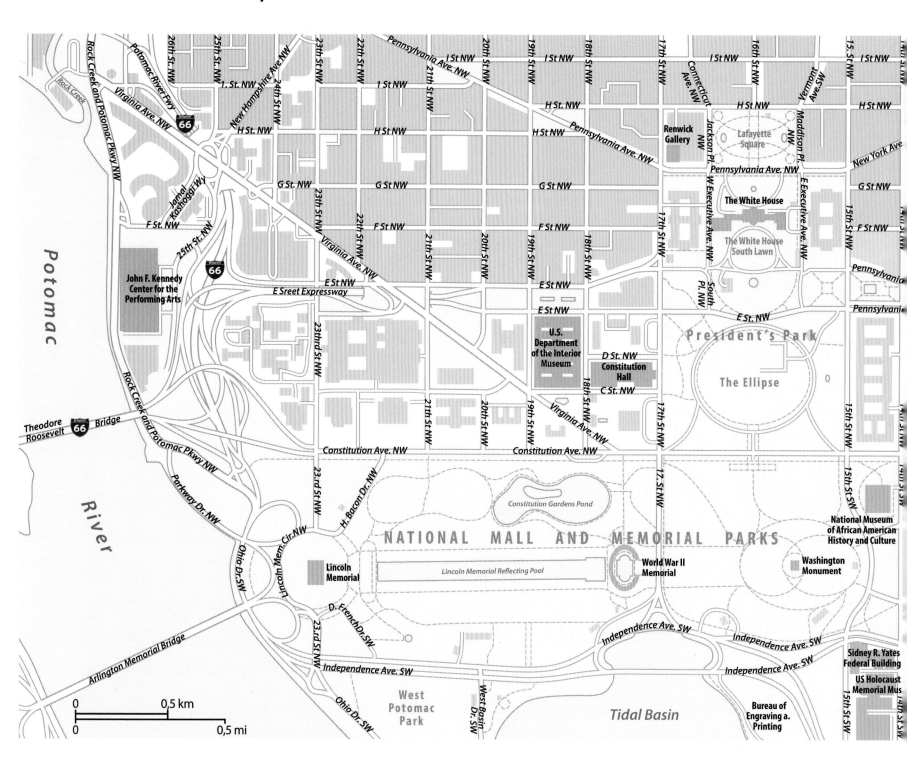

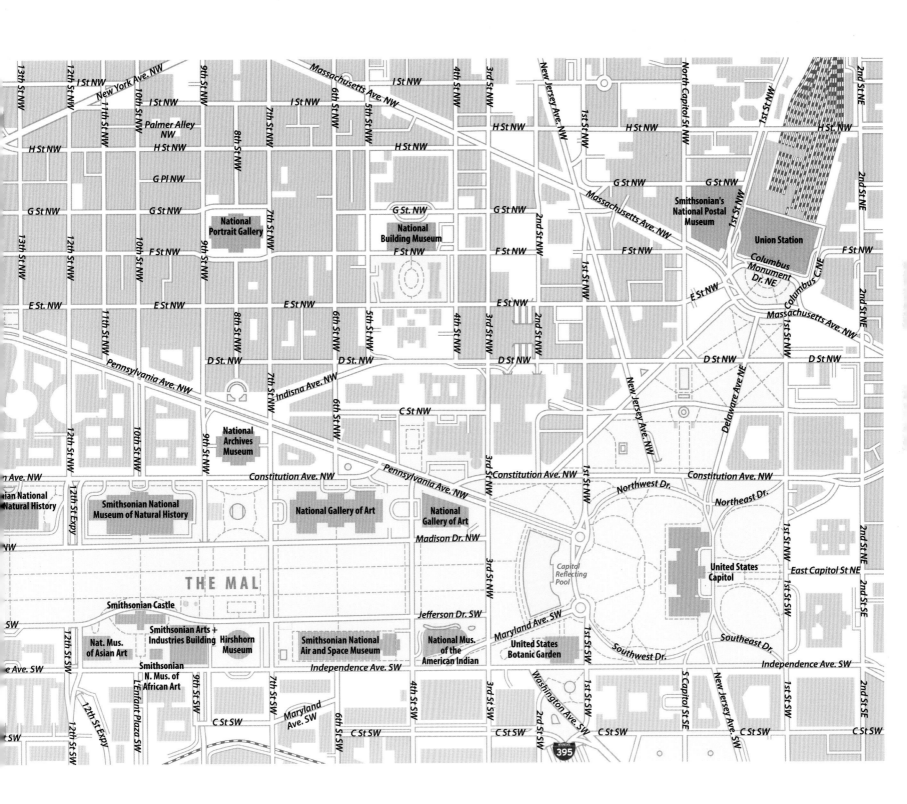

Although the idea of a tribute to the life and work of George Washington first arose at the Continental Congress of 1783, the cornerstone of the 555-foot monument in the shape of an Egyptian obelisk wasn't laid until July 4, 1848. Even then, the monument's construction repeatedly stalled, interrupted by the Civil War and a lack of funds. The Washington Monument was finally finished in 1884 and its reflection in the Reflecting Pool is one of the most photographed sites in the capital.

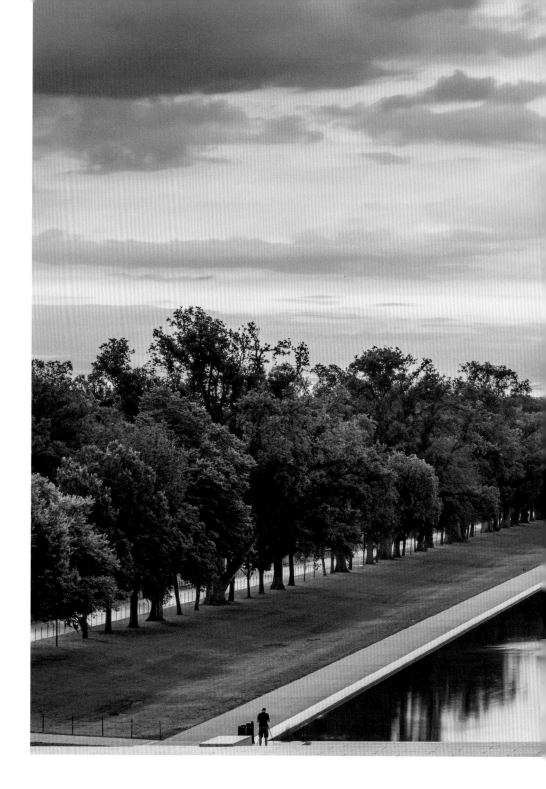

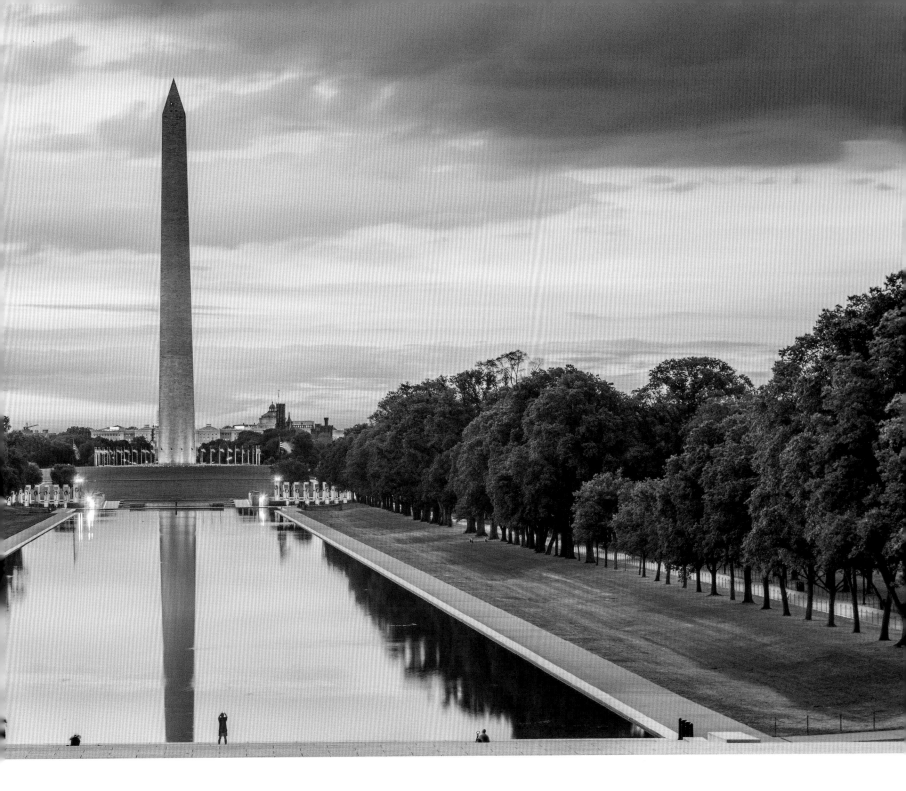

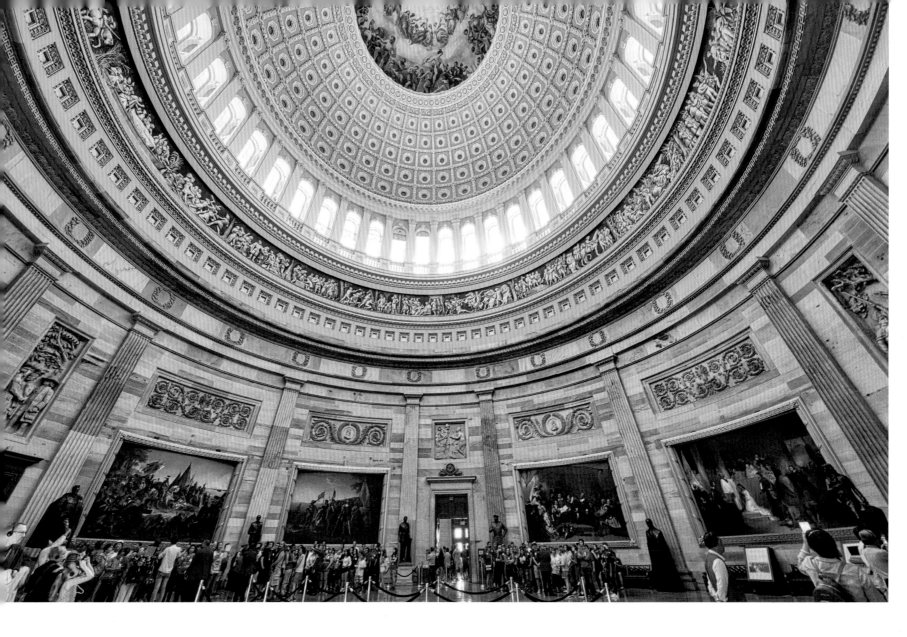

At night, the dome of the Capitol Building reflects in the Tidal Basin. The Capitol Building houses the United States Congress. The House of Representatives sit in the south wing and the Senate in the north wing. The building was partially burned in 1814 by British troops and the massive dome was completed just after the end of the Civil War. The U.S. Capitol Rotunda (above) is a large, domed, circular room located in the center of the Capitol.

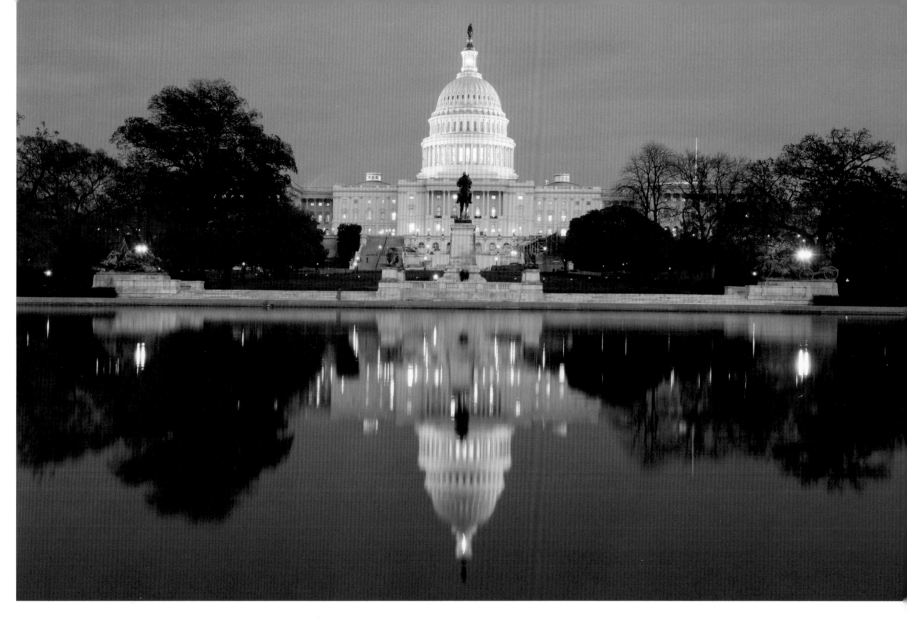

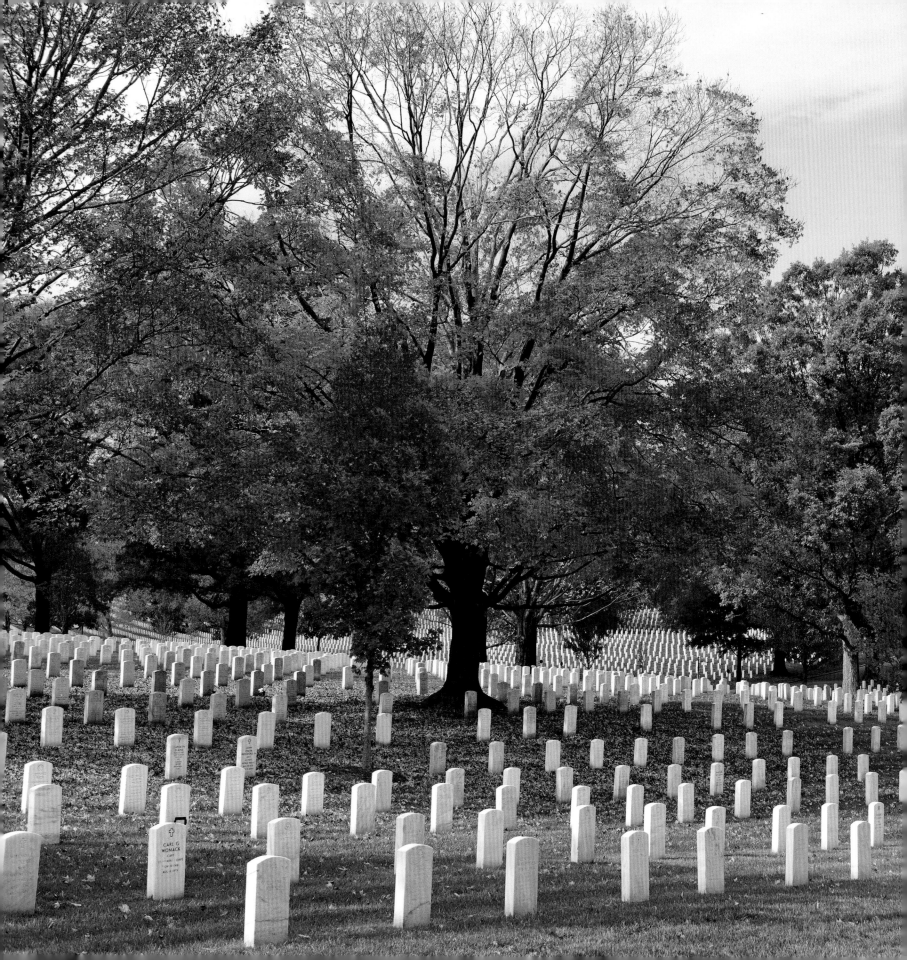

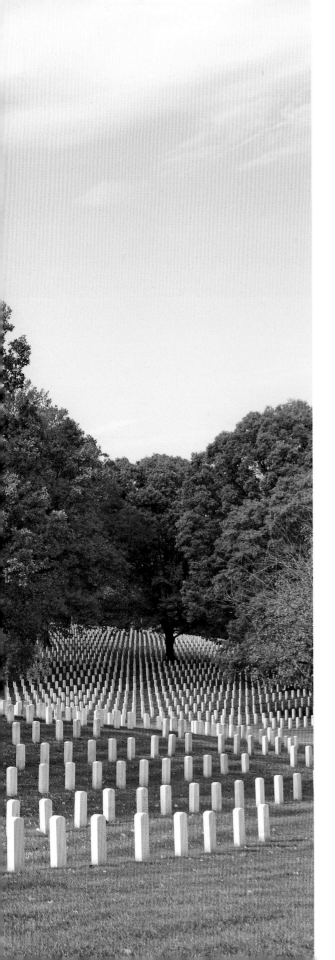

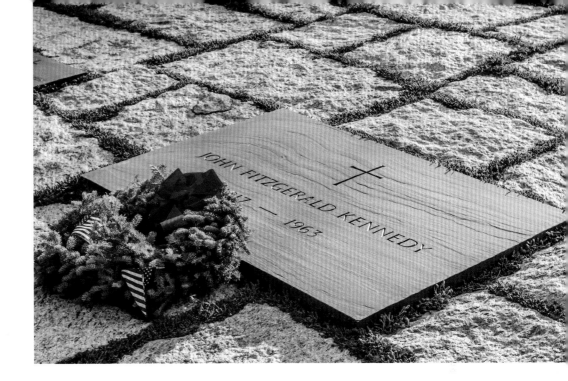

Six hundred and twenty four hilly, wooded acres overlooking the city from the west side of Memorial Bridge make up Arlington National Cemetery. More than 400,000 veterans and their eligible dependents are buried here. Five-star generals, such as John J. Pershing, and presidents, such as William Howard Taft, are buried alongside the remains of common soldiers and their widows. At the request of his wife, Jacqueline, John F. Kennedy's gravesite (above) includes an eternal flame, similar to that at the Tomb of the Unknown Soldier in Paris, France.

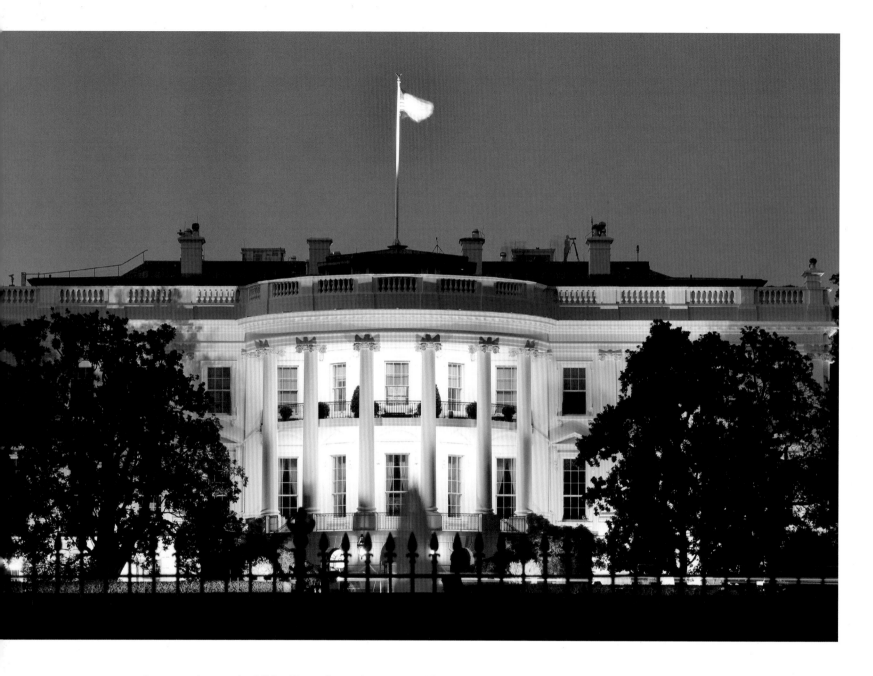

Construction on the White House began in 1792. President John Adams became the first resident of the unfinished White House on November 1, 1800. Since then, the building has served as residence, office and reception site for every president.

(Right) Marine One, the president's helicopter, takes off from the south lawn of the White House. The helicopter is used to take the president to Andrews Air Force Base, where the president's plane, Air Force One, is based, or to the presidential retreat at Camp David in Maryland.

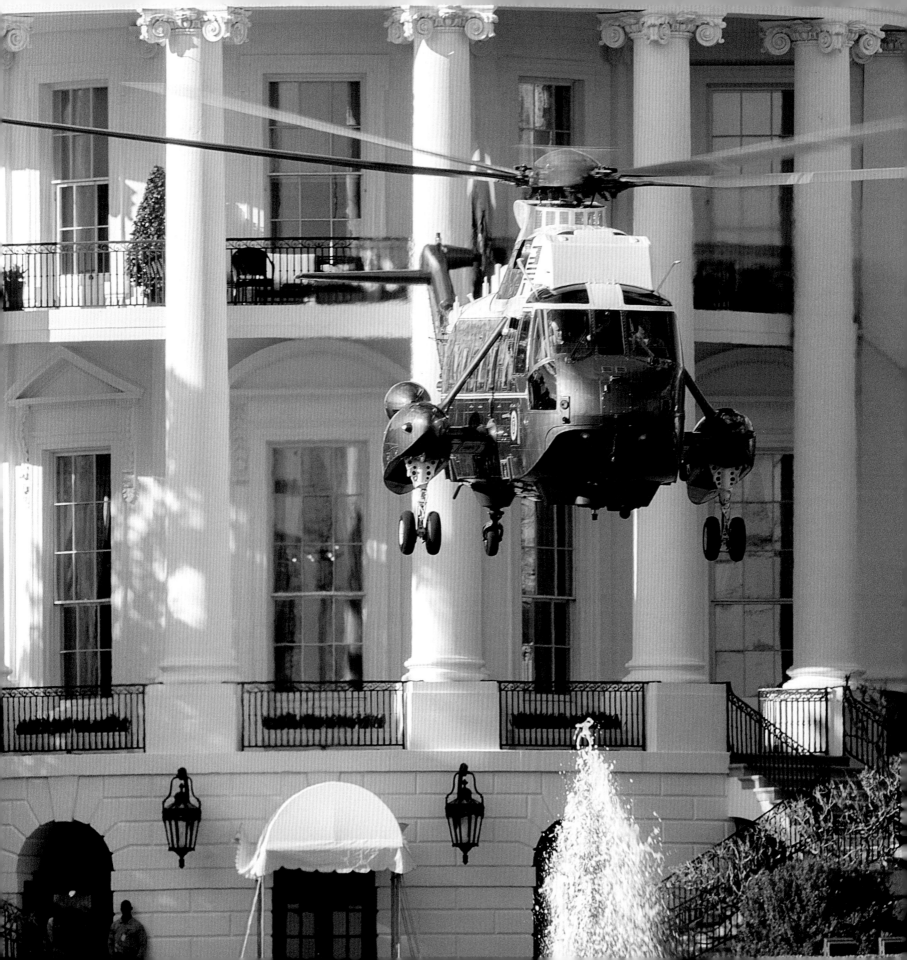

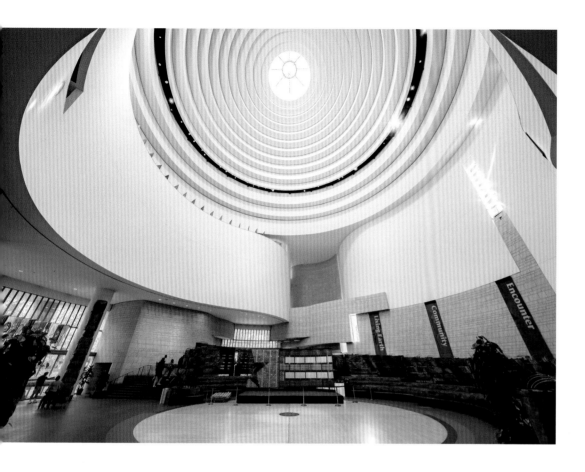

Opened in 2004, the National Museum of the American Indian, part of the Smithsonian Institution, is a strikingly handsome structure whose undulating sand-colored limestone walls distinguish it from the rest of the buildings along the National Mall. Thousands of objects and many exhibits showcase the culture and history of America's native peoples. The dome of the main exhibition hall (above), and the entrance are particularly impressive.

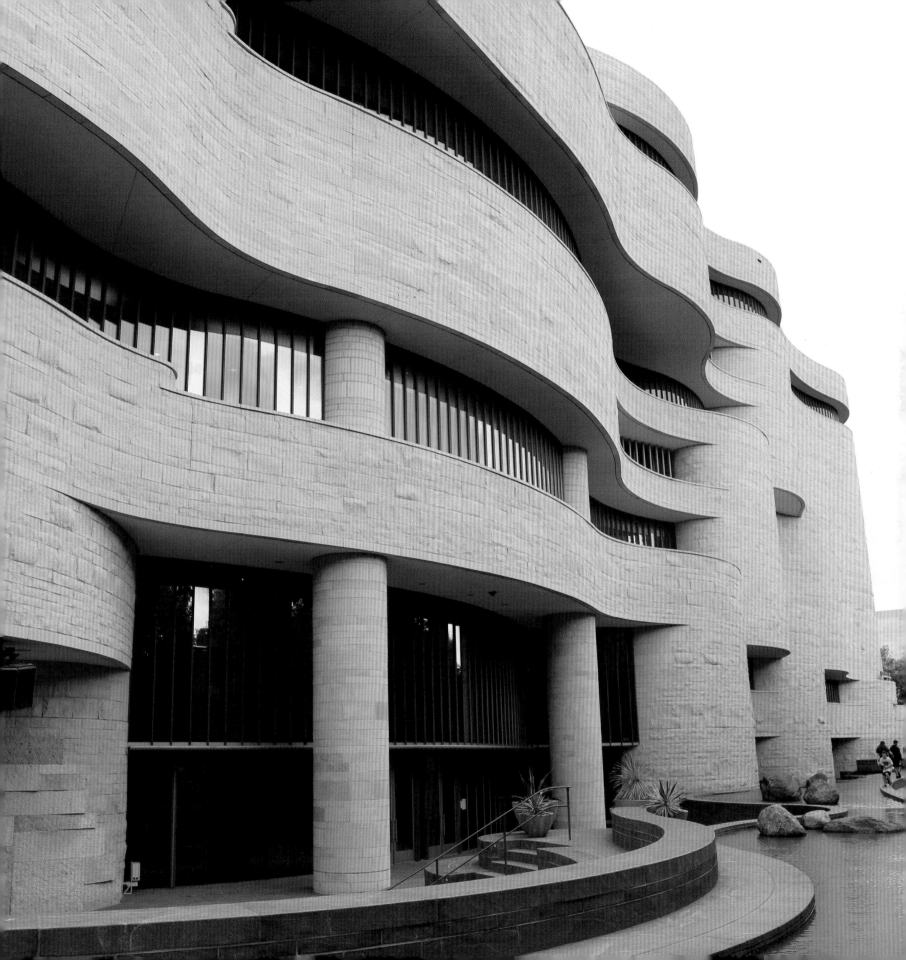

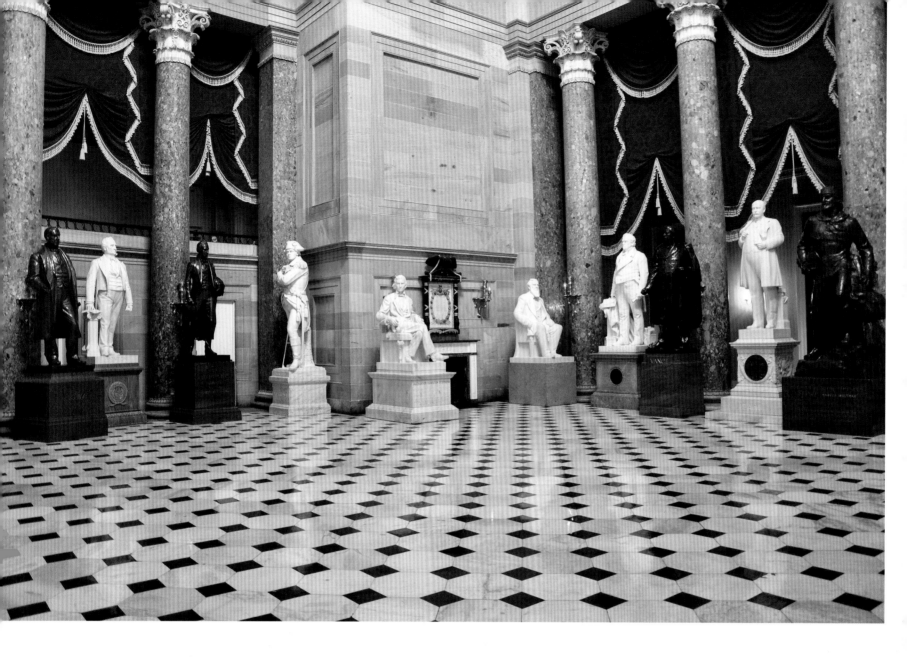

One of the most popular attractions in the National Capitol Building is a tour through the Rotunda, Statuary Hall and Crypt, where the history of the nation is showcased in a beautiful architectural setting.

(Right) At the entrance to the National Archives building stands this statue. Named *Future*, it was carved by Robert Aitken in 1935. It shows a woman with an open book on her lap, deep in thought about the future of the nation.

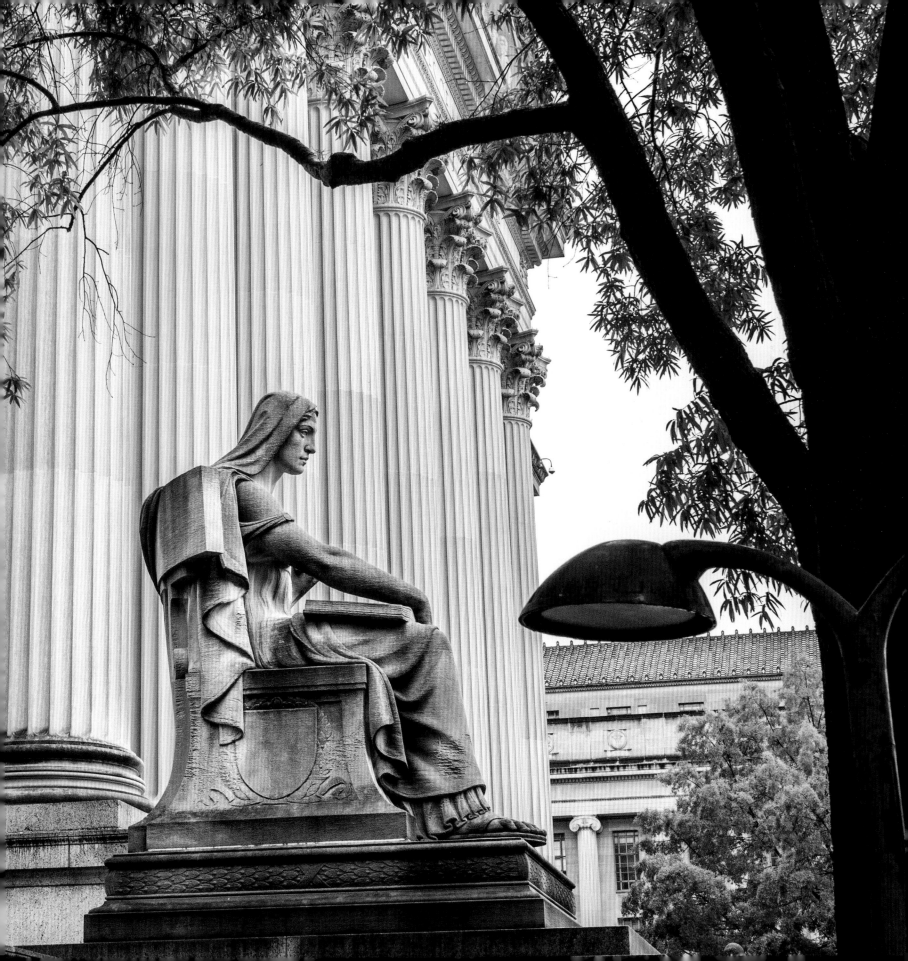

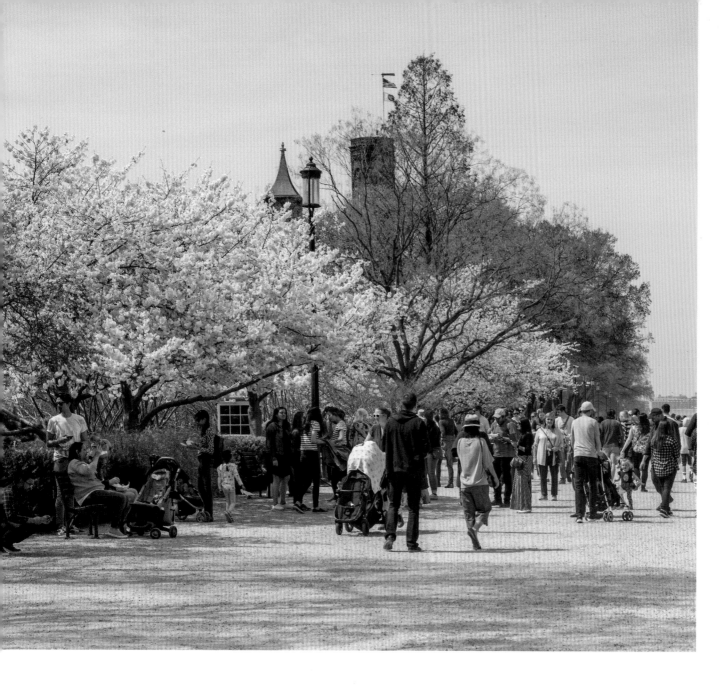

Tourists and residents alike enjoy the more than 3,000 cherry trees in bloom along the Tidal Basin. The trees usually start blooming in early April and continue for about two weeks.

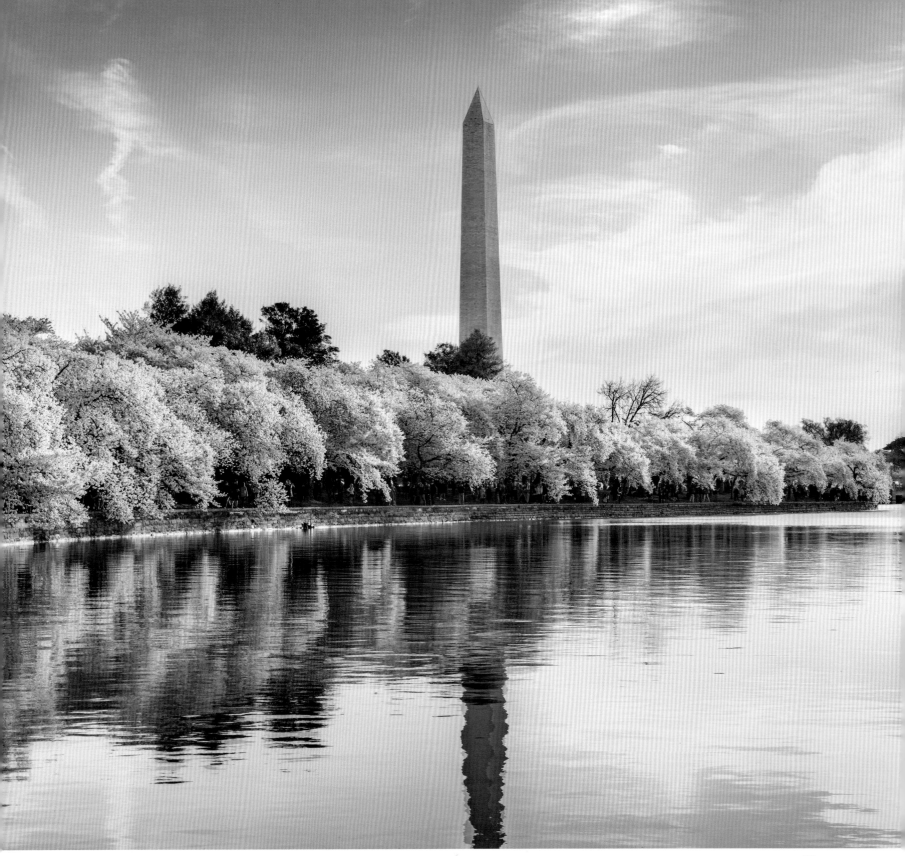

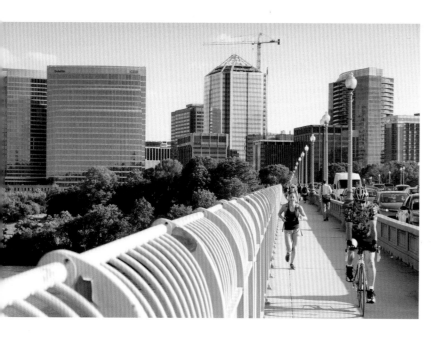

The six-lane Francis Scott Key Memorial Bridge, named for the man who wrote the words of the "Star-Spangled Banner," was completed in 1923. It is Washington's oldest bridge still spanning the Potomac and is a major traffic artery in the city for people on foot, bicycle and in cars.

(Right) Chinatown is a small historic neighborhood anchored by numerous Asian restaurants and the Capital One Arena. In 1986 the city erected this dramatic Friendship Archway with its seven roofs, 272 painted dragons and more than 7,000 tiles.

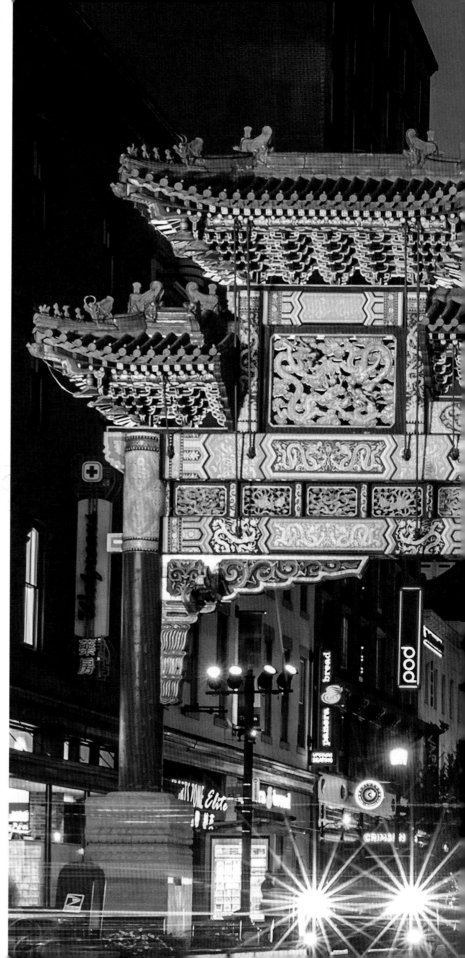

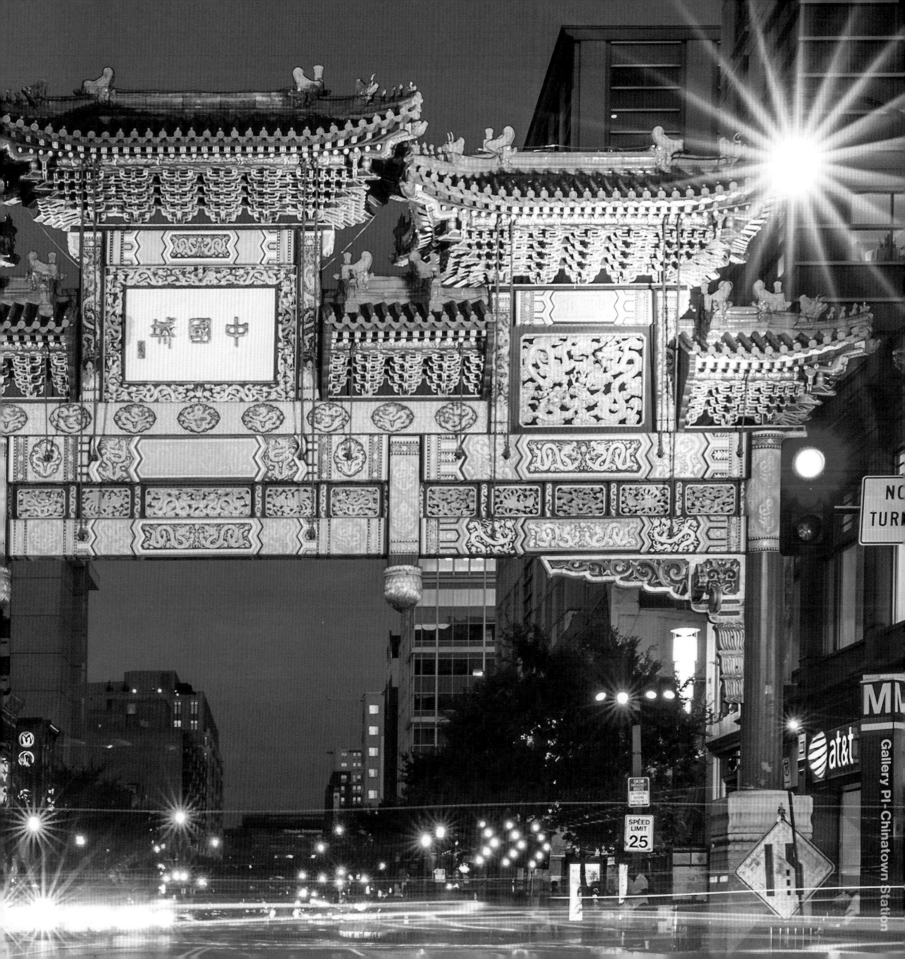

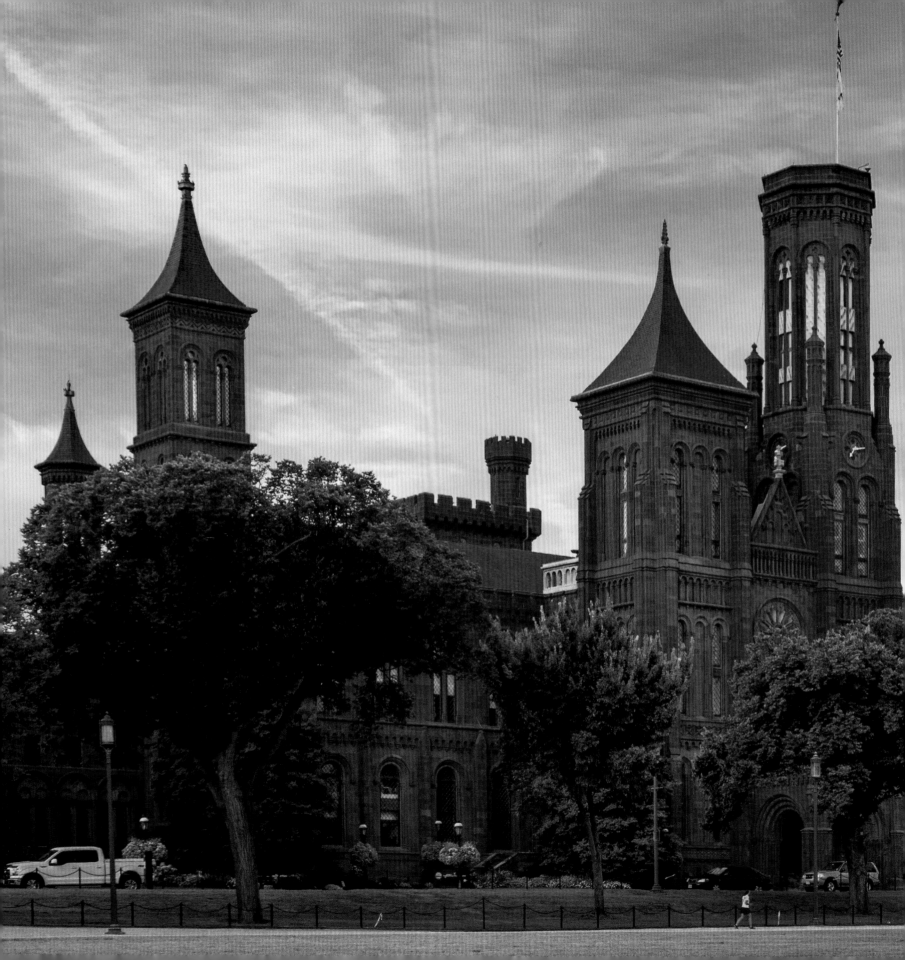

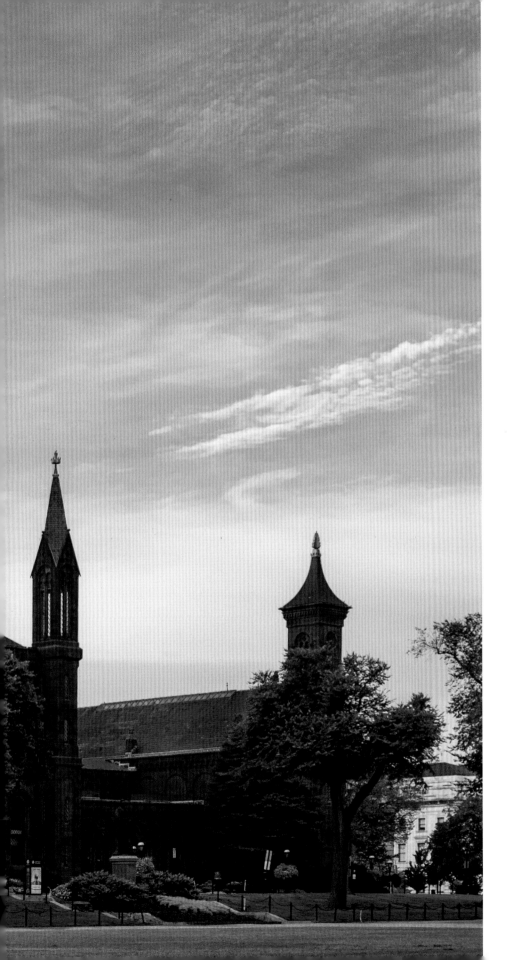

Commonly known in the city as The Castle, this Norman-style red-sandstone building dating from 1855 is the oldest on the Mall. It houses the offices of the Smithsonian Institution, which comprises 20 museums, research centers and a zoological park. More than 17 million people visit these museums annually and the Smithsonian's collection of millions of artifacts, most of which are not on view, continues to grow.

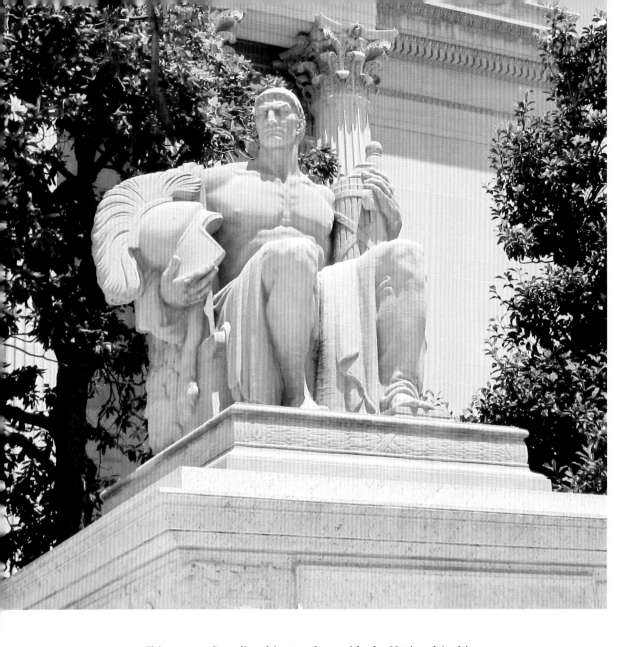

This statue, *Guardianship*, stands outside the National Archives building. The figure is holding a plumed helmet and a fasces, an ancient Roman symbol of authority and strength. At the base of the statue are the words "Eternal Vigilance is the Price of Liberty."

(Right) Dupont Circle connects the main thoroughfares of Massachusetts, New Hampshire and Connecticut Avenues. In the center of this busy area, known for its historic homes and trendy restaurants, is this beautiful marble fountain, installed in 1921.

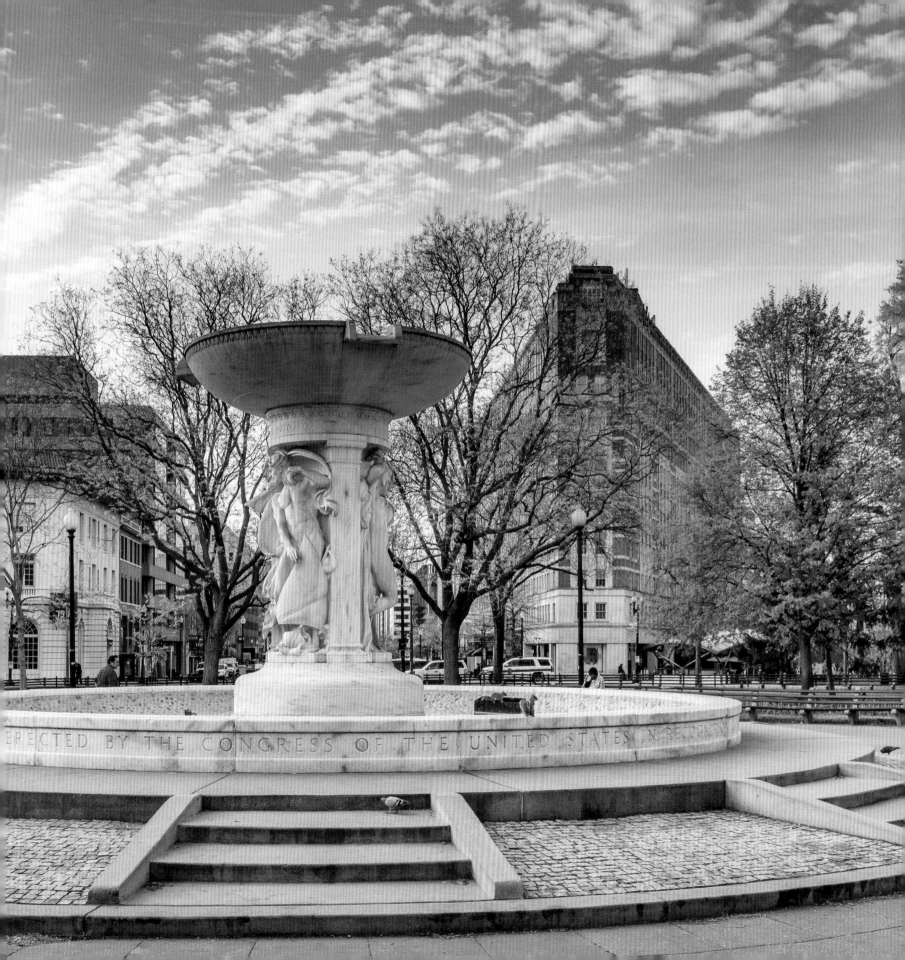

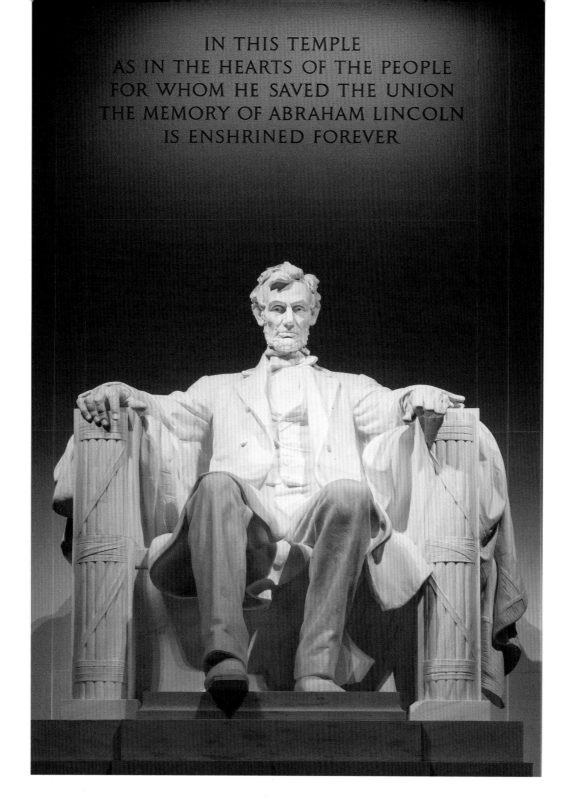

IN THIS TEMPLE
AS IN THE HEARTS OF THE PEOPLE
FOR WHOM HE SAVED THE UNION
THE MEMORY OF ABRAHAM LINCOLN
IS ENSHRINED FOREVER

Designed in the Neoclassical style, the Lincoln Memorial opened in 1922. The limestone walls of the Memorial's inner chamber, surrounding Daniel Chester French's famous statue of the president, are inscribed with the Gettysburg Address and Lincoln's Second Inaugural Address. A set of allegorical murals depicts Lincoln's achievements and values.

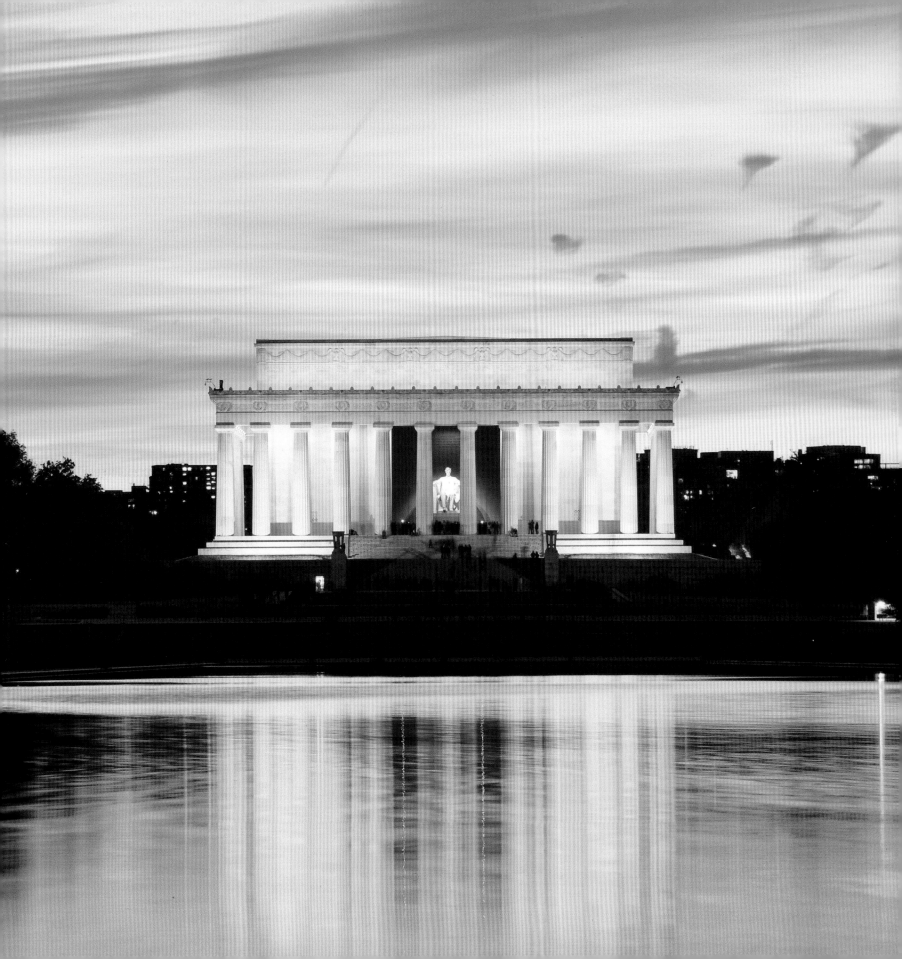

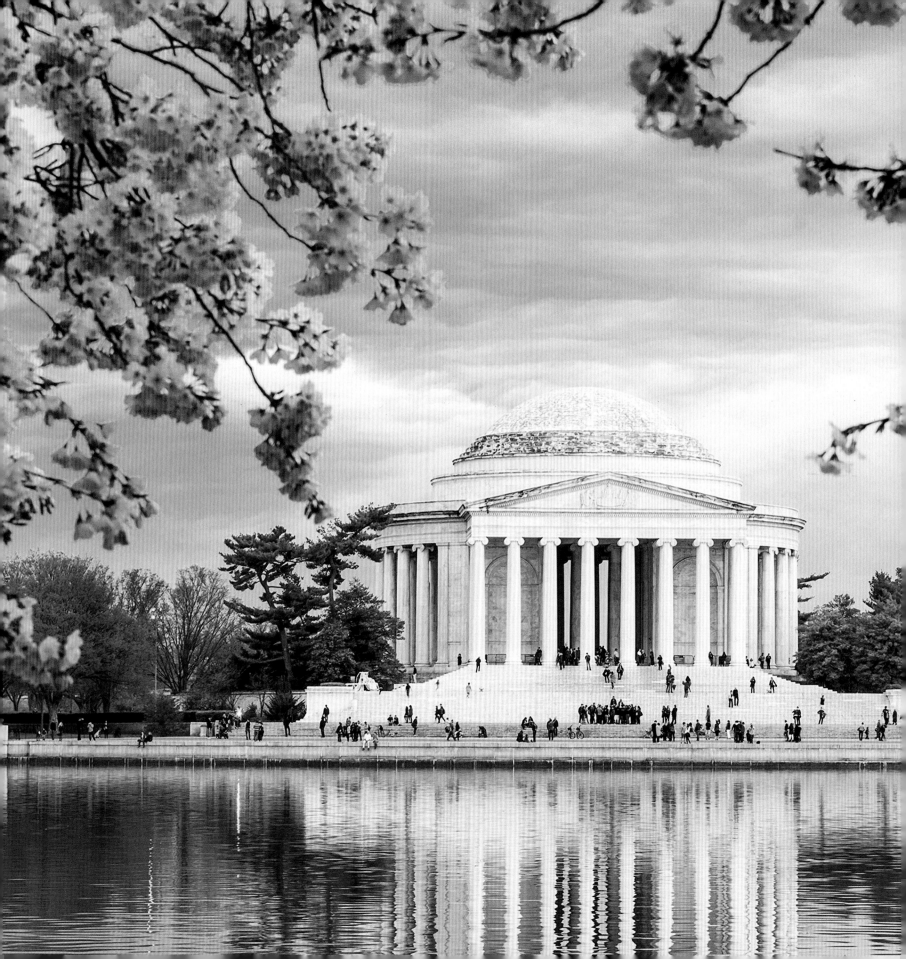

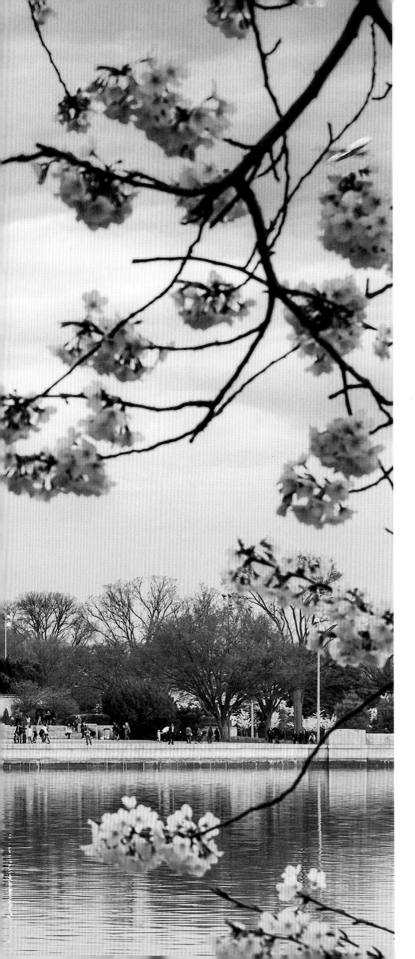

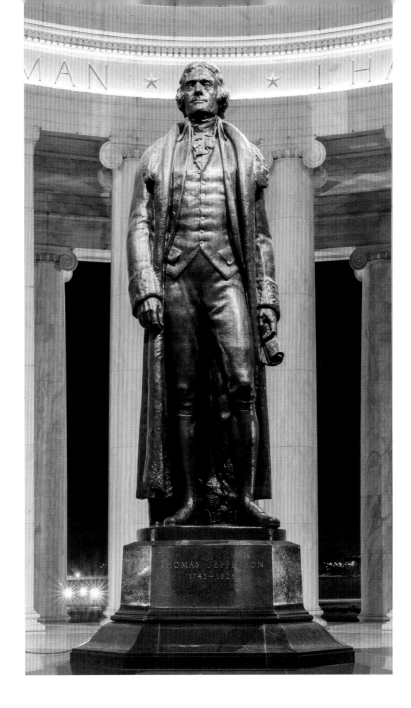

President Franklin Roosevelt led an effort to build a memorial to Thomas Jefferson in Washington. Land was reclaimed from the Potomac River and the cornerstone laid in 1939. Roosevelt had all the trees between the memorial and the White House cut down, allowing him to see the building every morning. In 1941 sculptor Rudolph Evans was commissioned to design a statue of Thomas Jefferson to fill the central interior space.

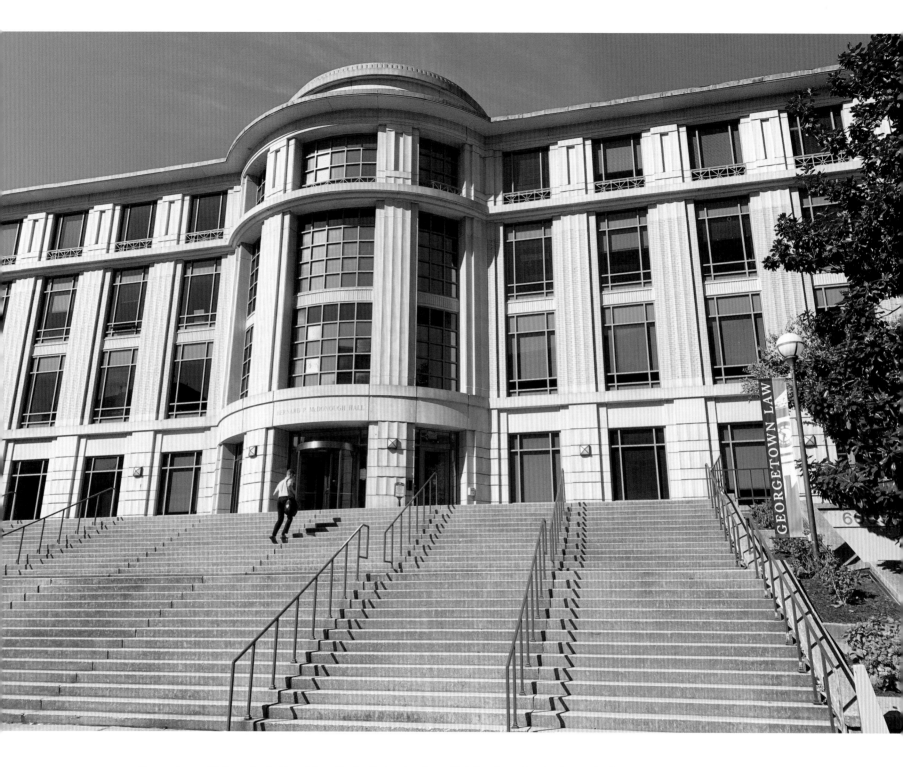

Georgetown University is the oldest Catholic institution of higher learning in the United States. Founded by John Carroll in 1789 on land overlooking the village of Georgetown, the university granted its first bachelor's degree in 1817. Georgetown Law School, now housed in this building, was established in 1870.

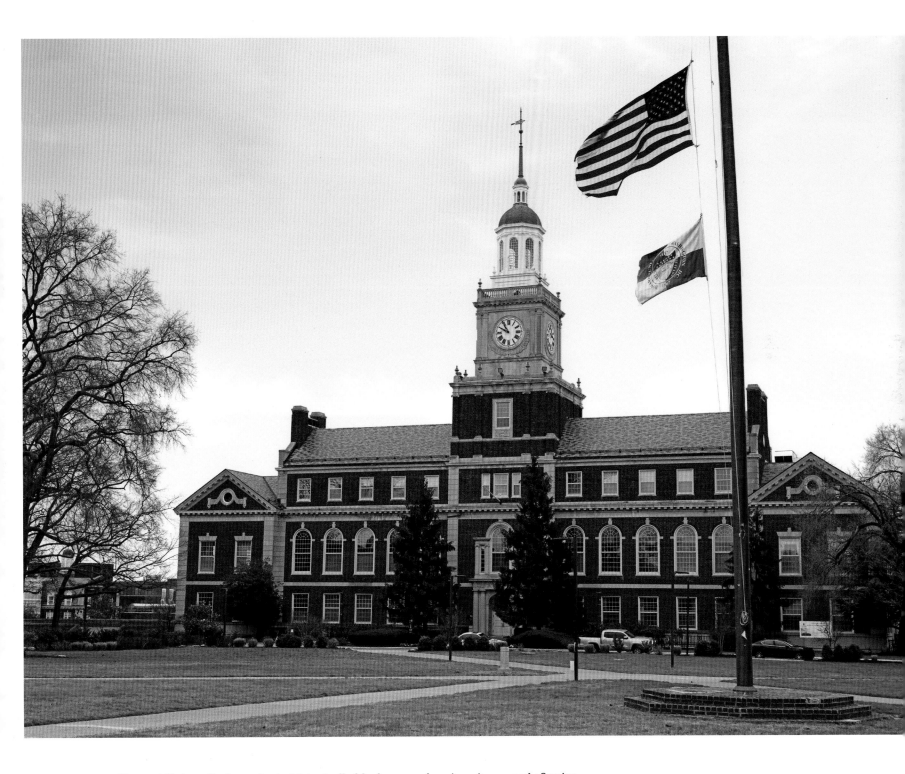

Howard University is a private, historically black research university named after its founder General Oliver Otis Howard. Howard, a Civil War hero, was a commissioner of the Freedmen's Bureau and served as president of the university from 1869 to 1874.

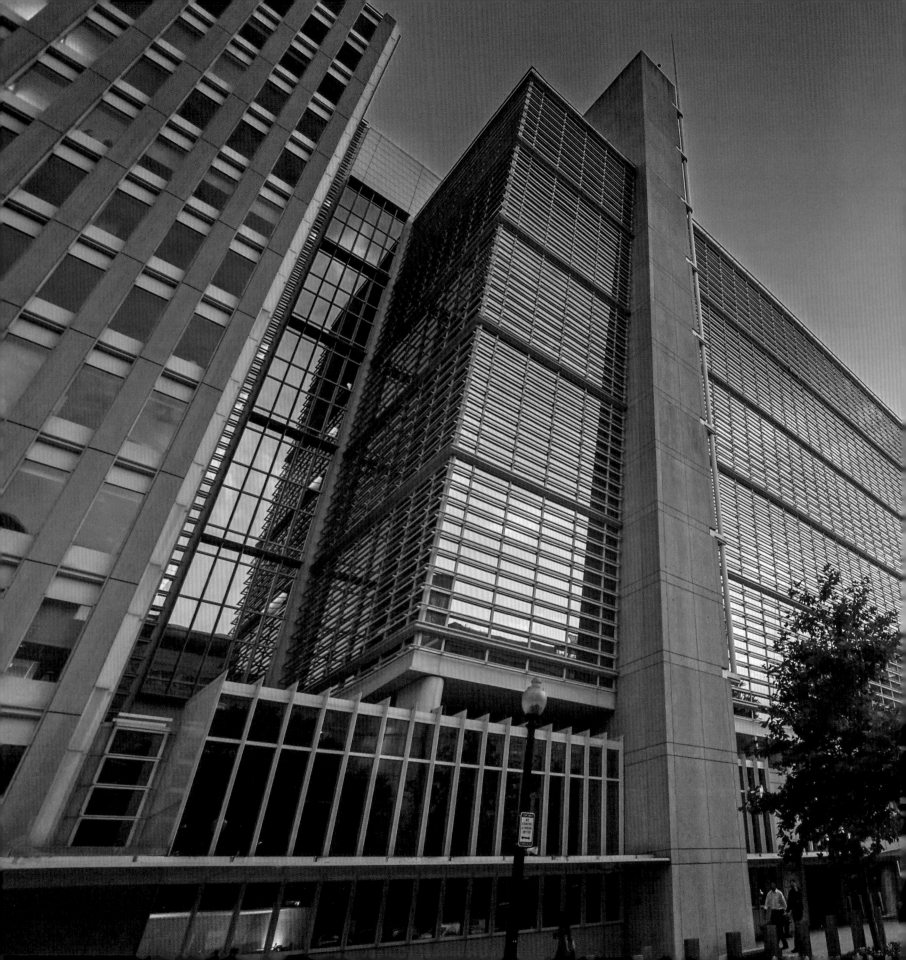

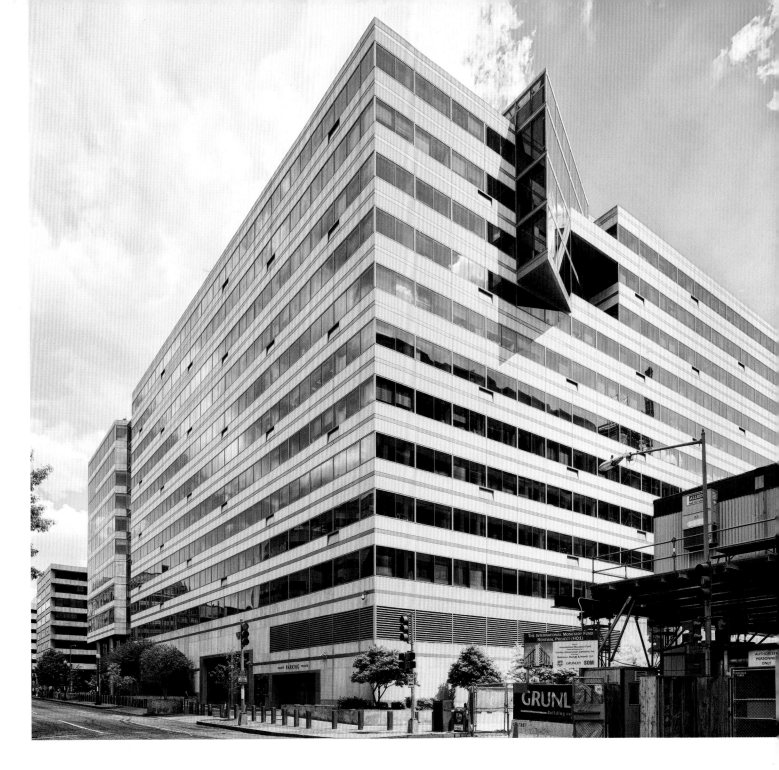

Although much of Washington, DC, is dominated by neoclassical architecture, modern buildings with striking designs are also found in the city. The World Bank Inspection Panel (left) is housed in this building on H Street. The International Monetary Fund building (above) is on Pennsylvania Avenue.

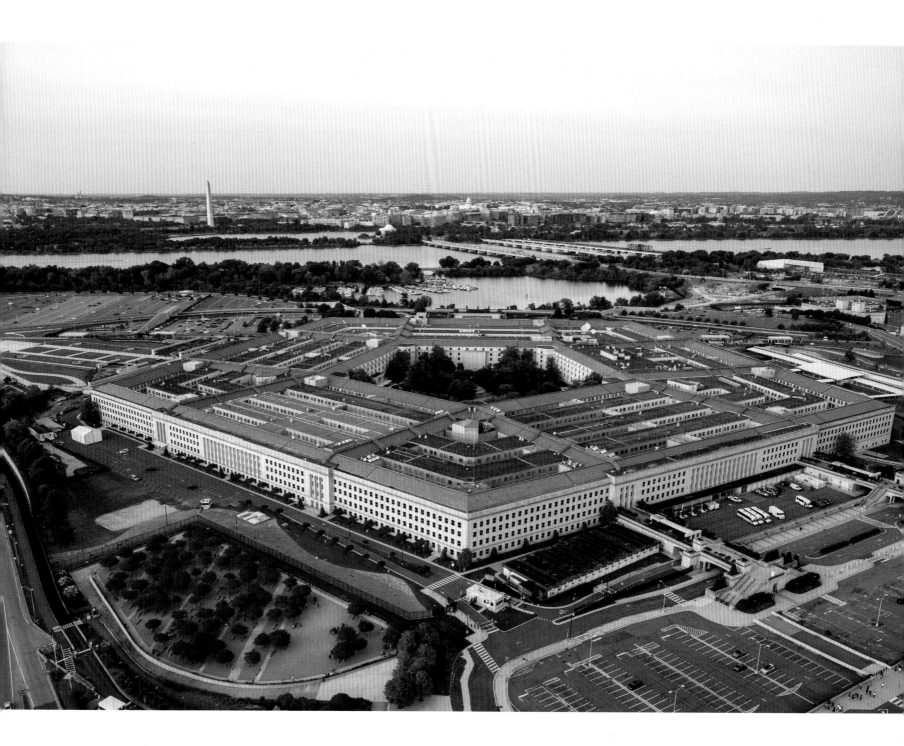

The Pentagon, headquarters of the Department of Defense, is the second largest office building in the world. The building houses 27,000 employees, has 17.5 miles of corridors and occupies 6.5 million square feet of floor space. The five-sided building was constructed in the early years of the Second World War. It is located in Arlington, Virginia, across the Potomac River from Washington, DC.

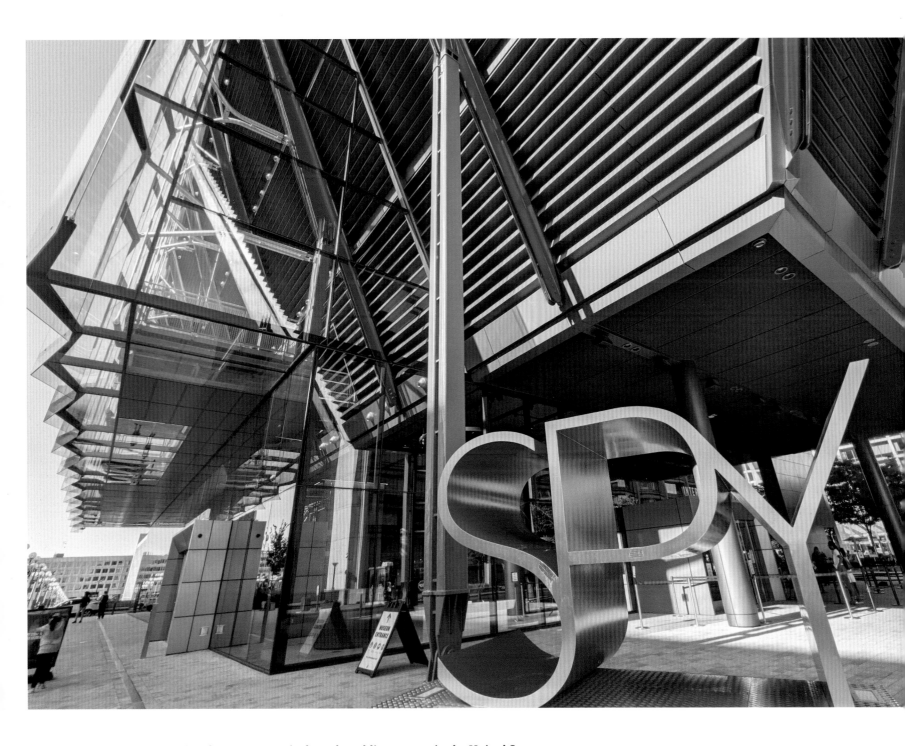

The International Spy Museum is the only public museum in the United States dedicated solely to the art and adventure of espionage. Besides tools of the trade (both ancient and modern), biographies of famous spymasters and numerous audio-visual displays, the museum boasts interactive exhibits and attracts more than 600,000 visitors a year.

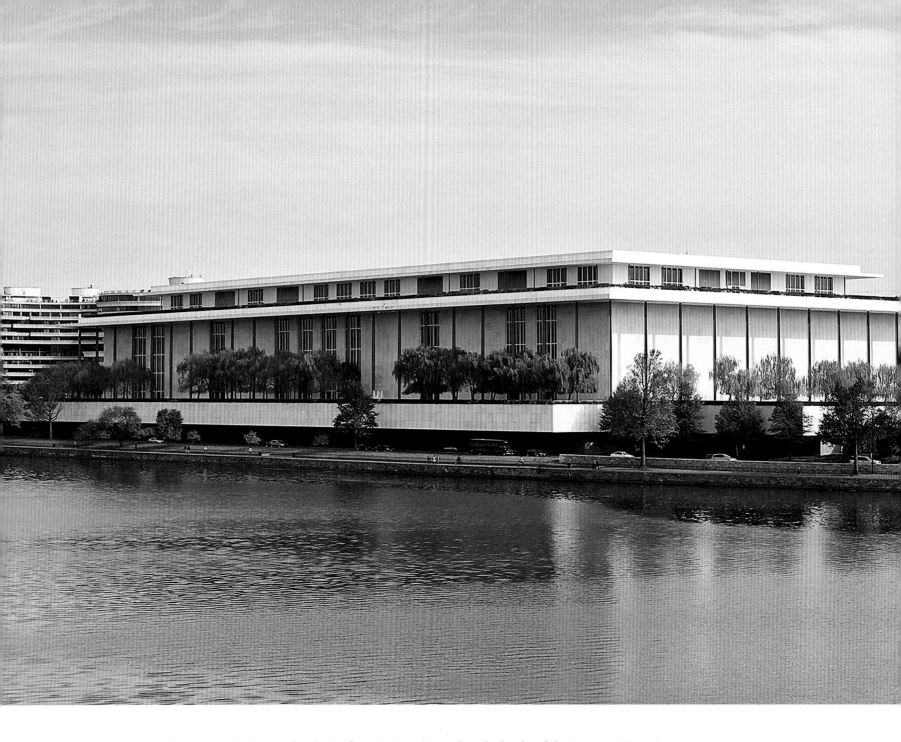

The John F. Kennedy Center for the Performing Arts, located on the banks of the Potomac River, is a national performing arts center with an opera house, concert hall, theaters and a memorial to the president. The interior of this striking building is filled with art, treasures and objects donated by foreign countries in President Kennedy's memory.

(Right) The Grand Foyer of the Kennedy Center is one of the largest rooms in the world. At 63 feet high and 630 feet long it could, if laid on its side, contain the Washington Monument — with 75 feet to spare.

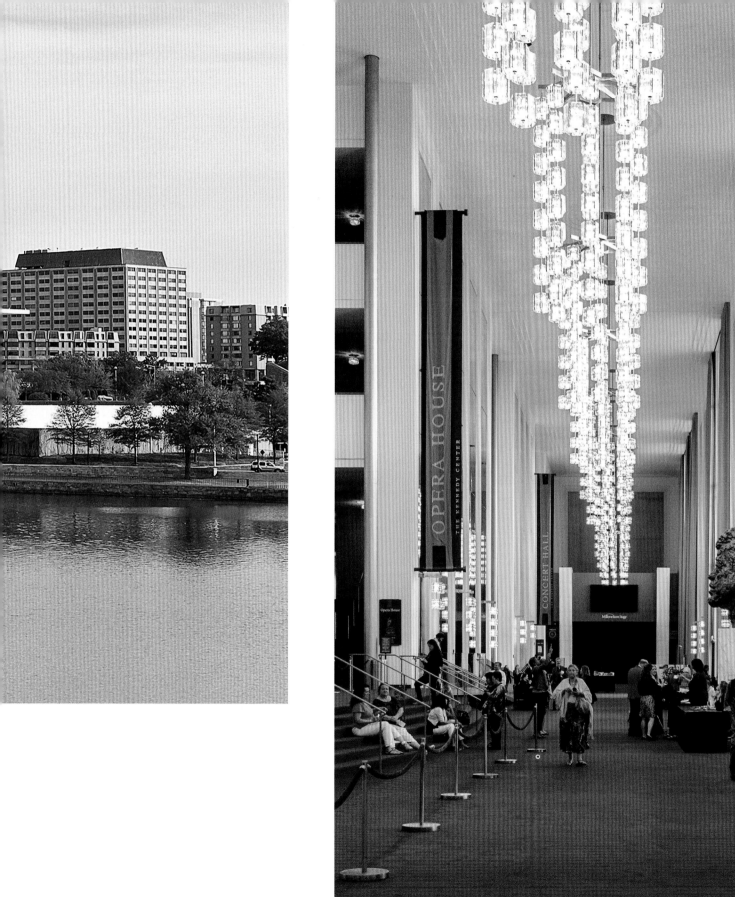

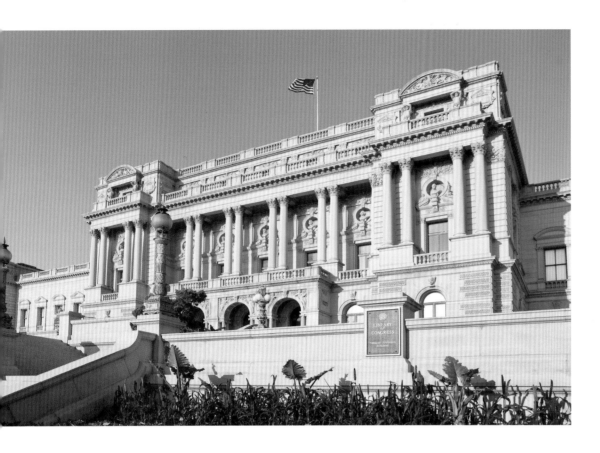

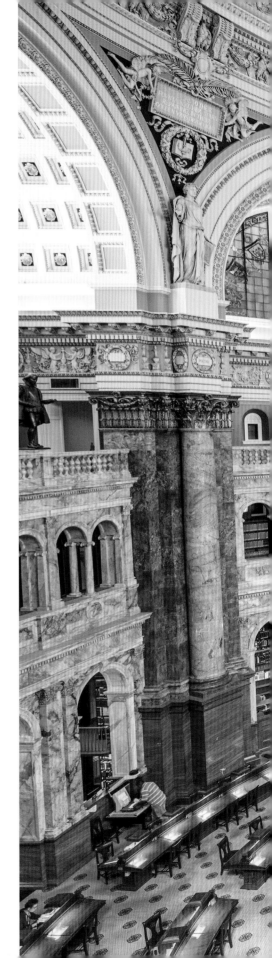

The Library of Congress officially serves the members of the U.S. Congress but also houses and preserves government archives and records. The Reading Room (right) is primarily for use by members of Congress but is also open to members of the public who apply to use the library for research purposes.

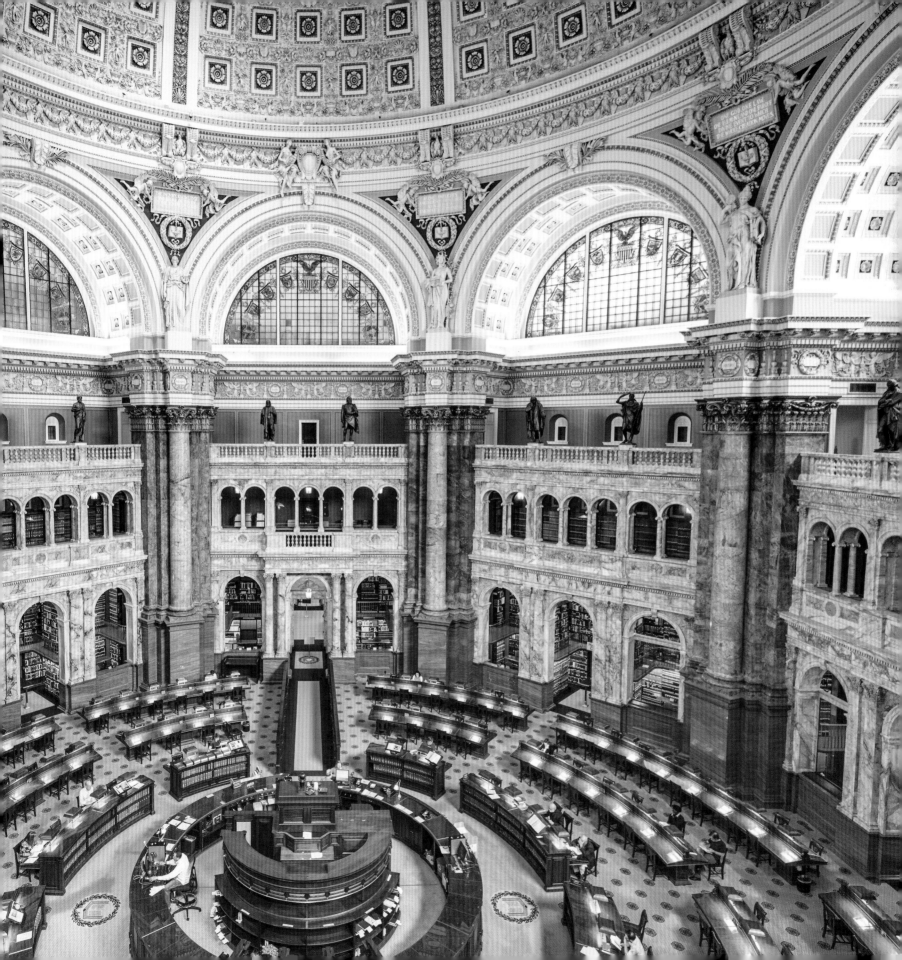

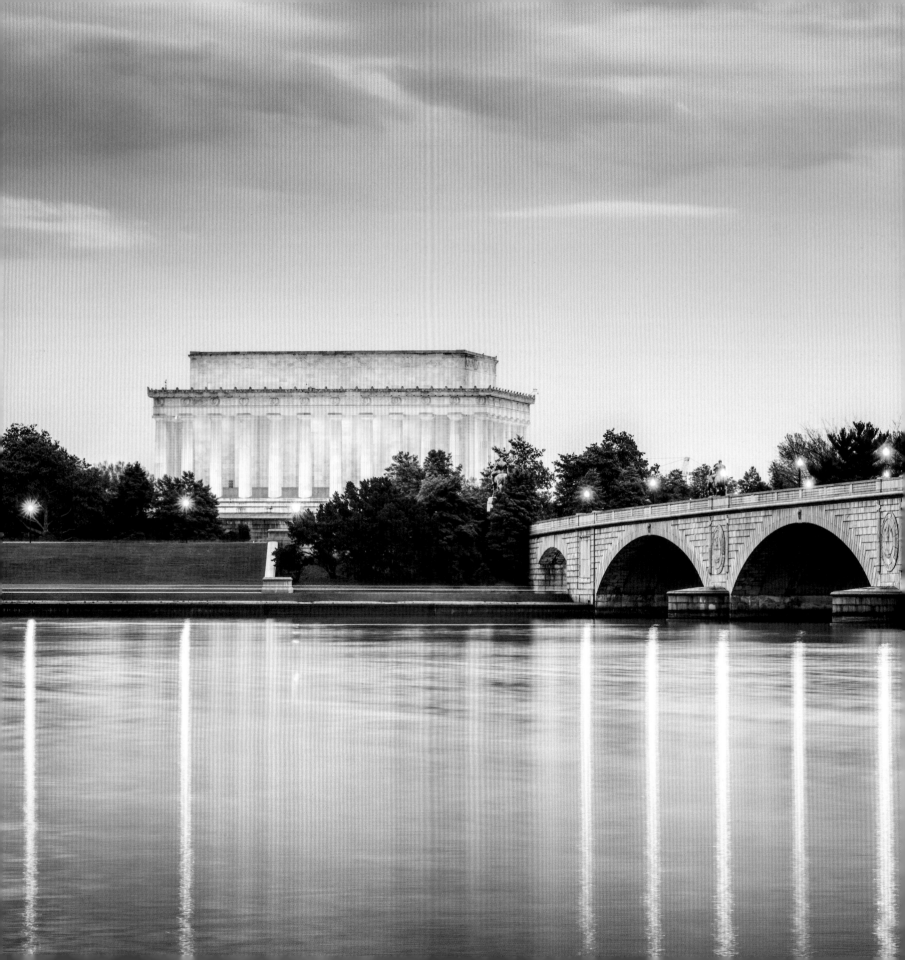

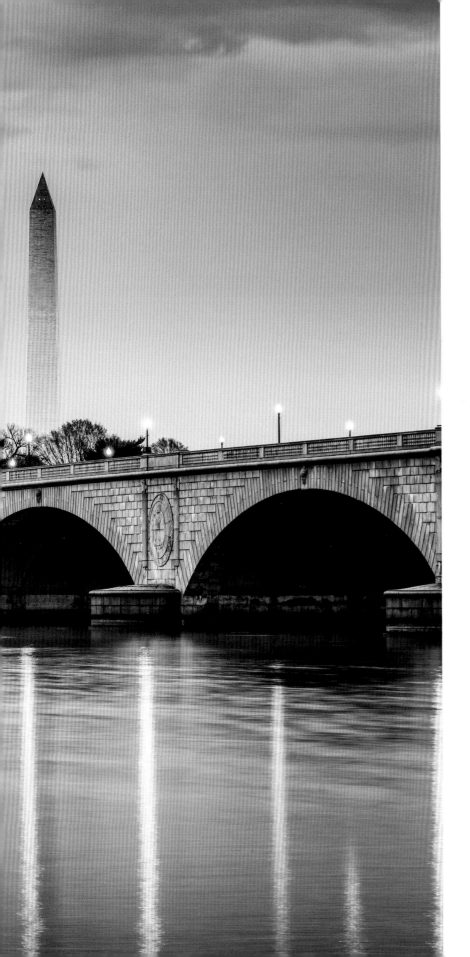

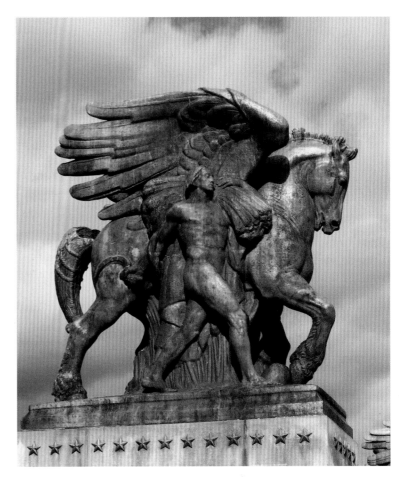

Constructed between 1926 and 1932, the Arlington Memorial Bridge, which marks the end of the National Mall and leads to Arlington National Cemetery, is composed of nine broad arches that stretch 2,100 feet over the Potomac River. Adorned with statuary, the bridge is considered to be the city's most beautiful. Two 17-foot pairs of bronze equestrian statues (above) mark the ends of the structure.

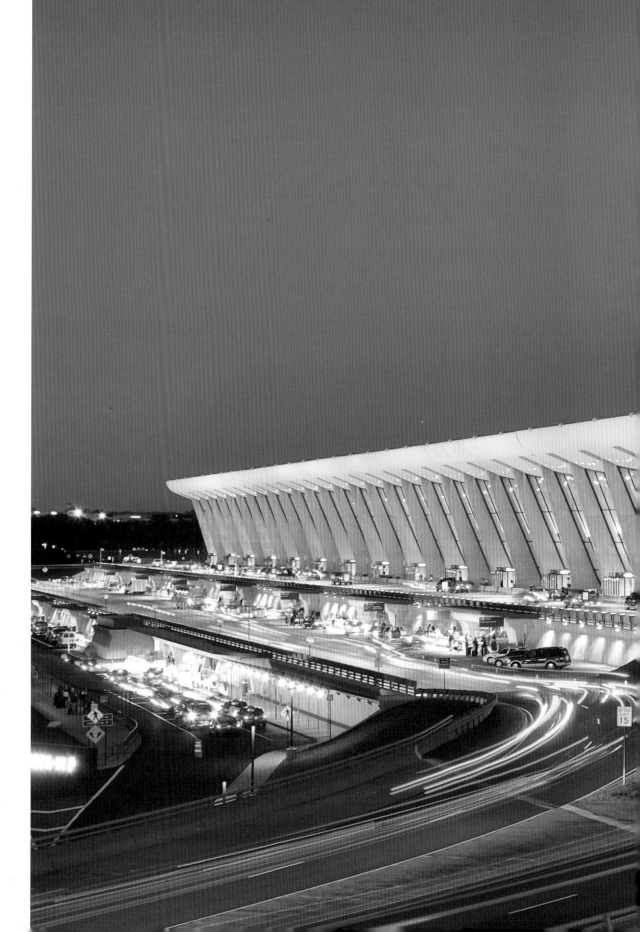

Dulles International Airport in Northern Virginia is a major gateway to Washington, DC. It handles more international traffic than any other airport on the east coast except for New York. The stunning architecture was designed by Eero Saarinen. The airport is named after former Secretary of State John Foster Dulles.

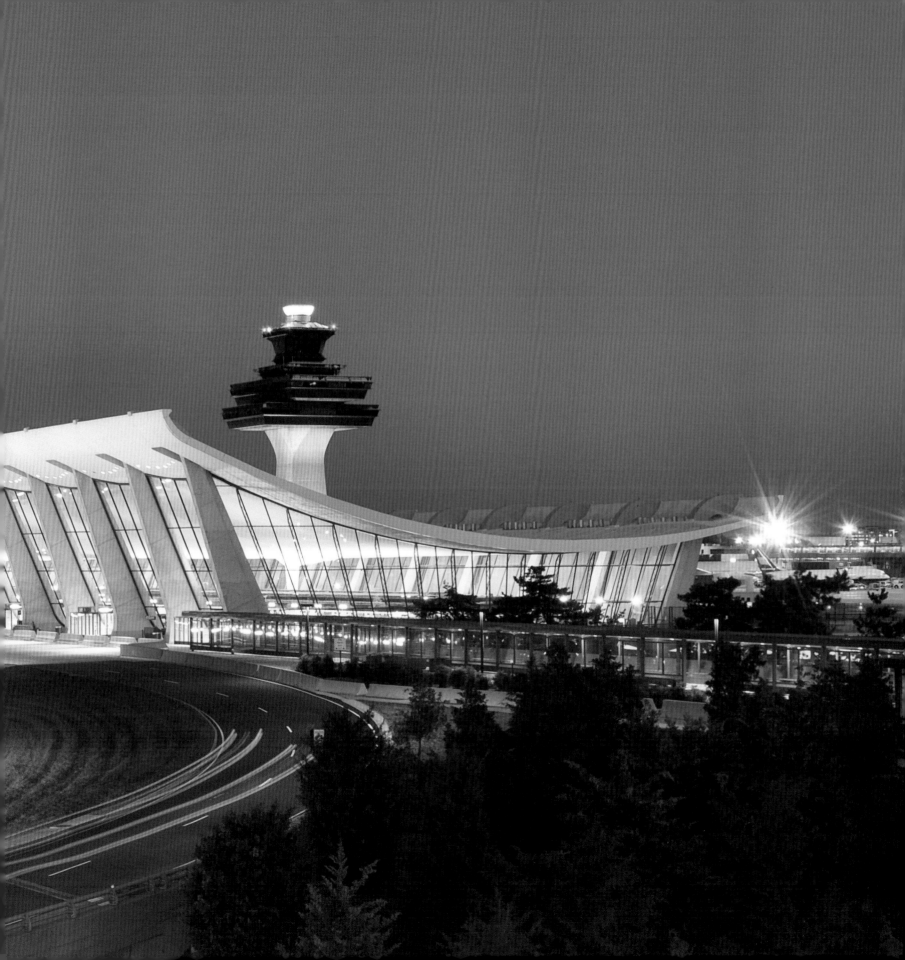

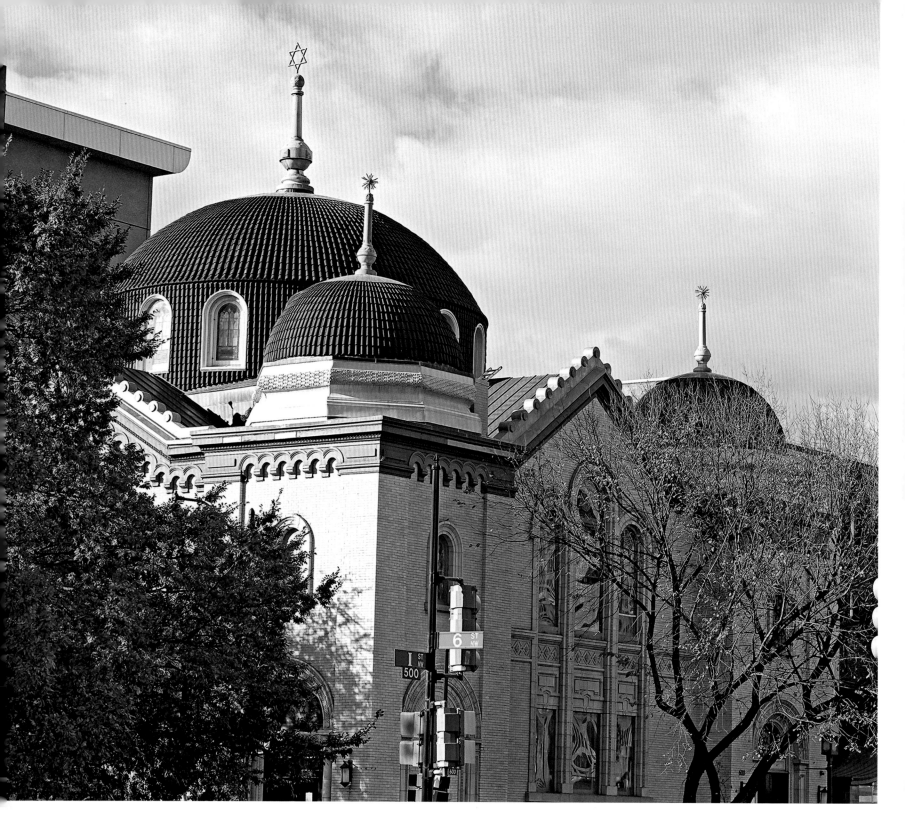

The historic Sixth & I Street Synagogue is a non-denominational, non-membership, non-traditional Jewish congregation and synagogue. One of the oldest synagogues in the city, it is a center for arts, entertainment, ideas and Jewish life in the city.

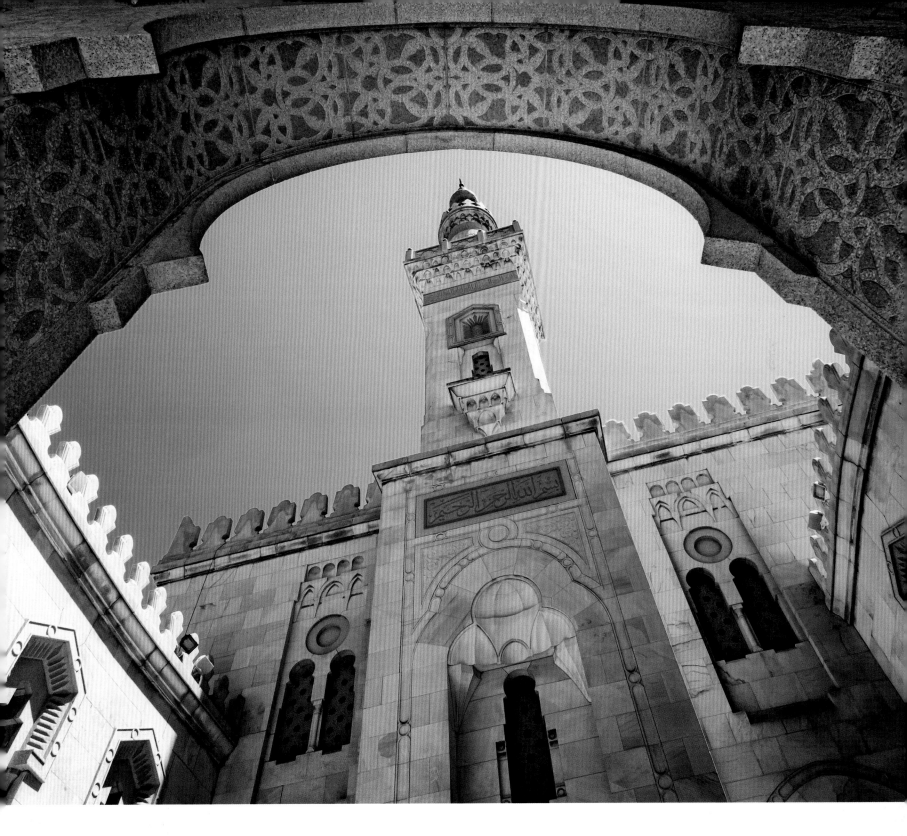

The Islamic Center of Washington's interior courtyard, with its beautiful mosaics and 162-foot minaret, was dedicated in 1957. It is the oldest Islamic place of worship in Washington, DC.

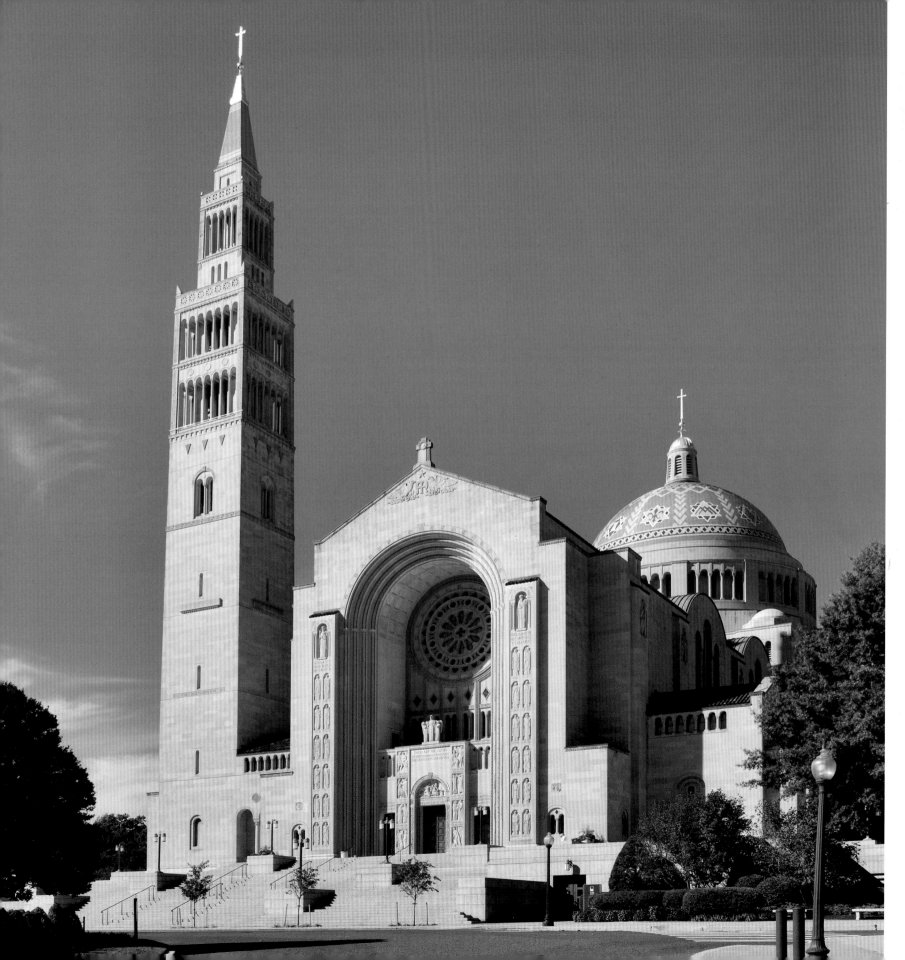

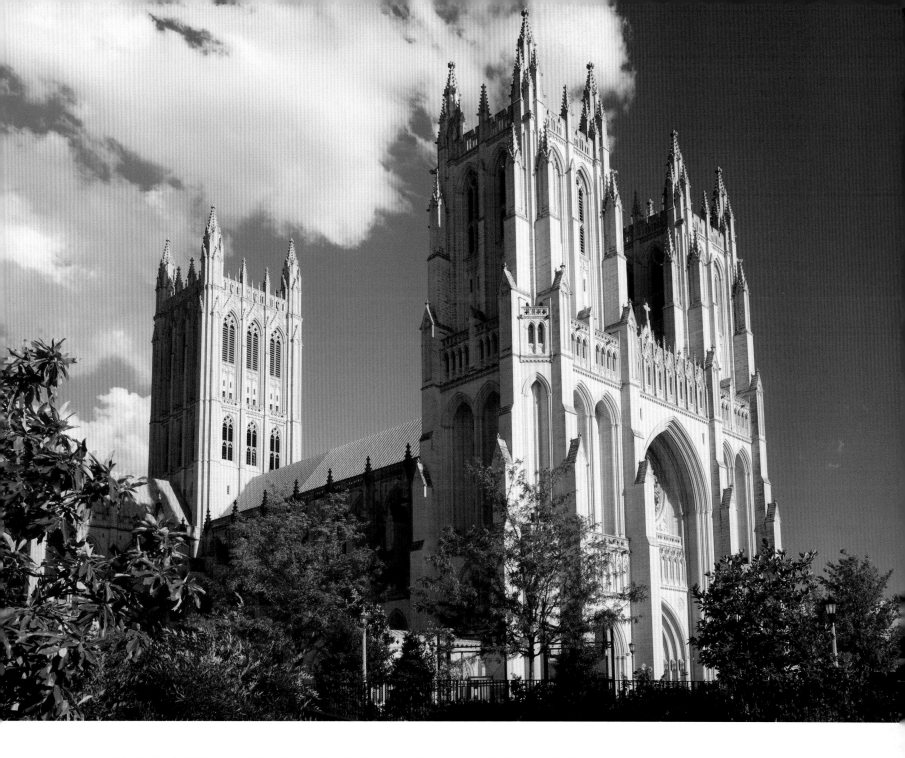

The Cathedral Church of St. Peter and St. Paul, commonly known as Washington National Cathedral, is built in the English Gothic style. A stained-glass window commemorating the flight of Apollo 11 contains a piece of actual moon rock.

(Left) The Basilica of the National Shrine of the Immaculate Conception is the largest Roman Catholic church in North America and the tallest habitable building in Washington. The basilica holds the world's largest collection of contemporary ecclesiastical art and is known for its brilliant mosaics.

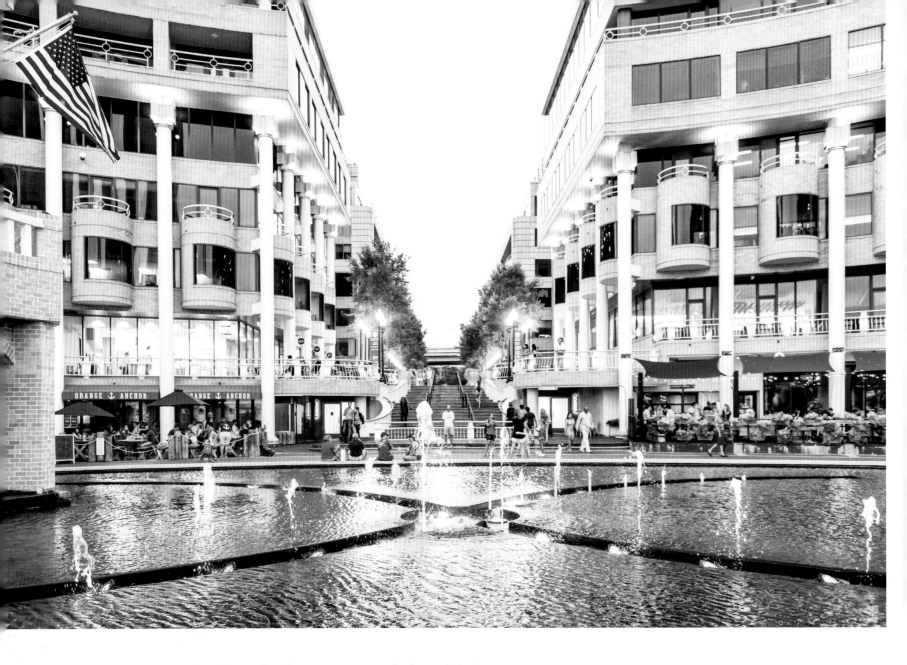

Shops and residences line the waterway near the fountain in Georgetown Waterfront Park Harbor. The park contains a fountain, a labyrinth and more than 225 miles of parkland along the Potomac River.

The Walter E. Washington Convention Center contains over 2 million square feet of space. In addition to trade shows, conventions and other events, the center has been the site of several Presidential Inauguration Balls, including six of the 10 official balls for the inauguration of President Barack Obama.

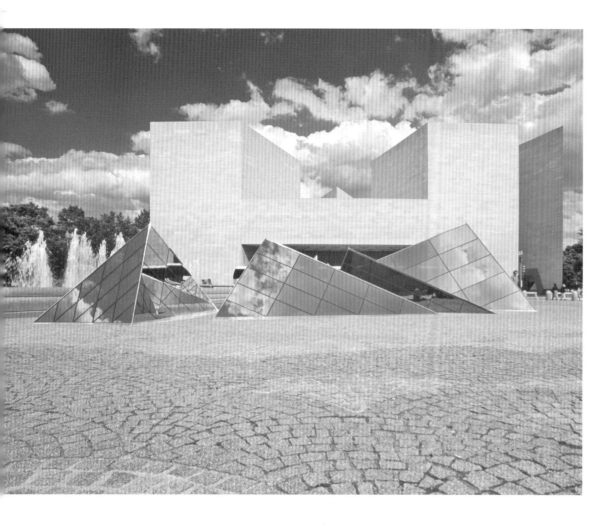

The East Building of the National Gallery of Art opened in 1978. Among the world's foremost museums, the National Gallery of Art has a rotating collection of more than one hundred thousand works. The architecture of the building is world famous and was designed by architect I.M. Pei and his team.

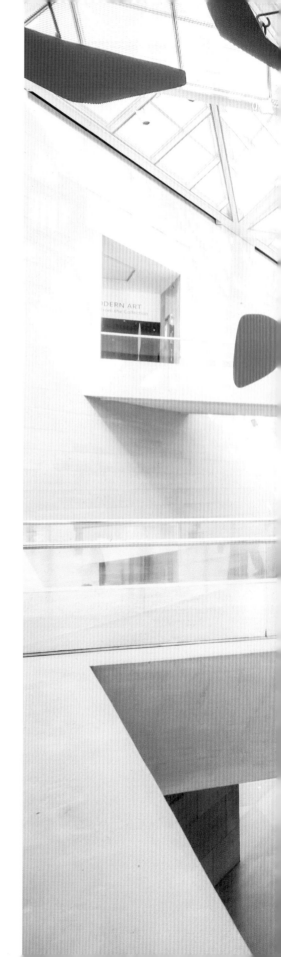

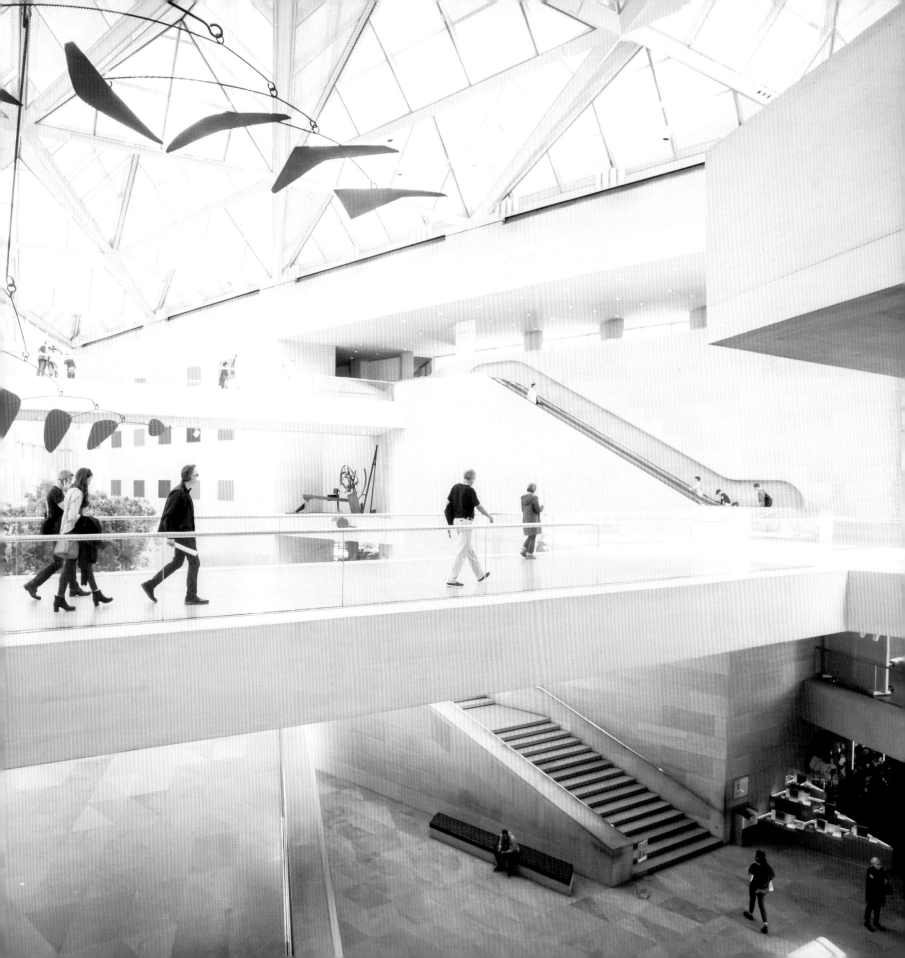

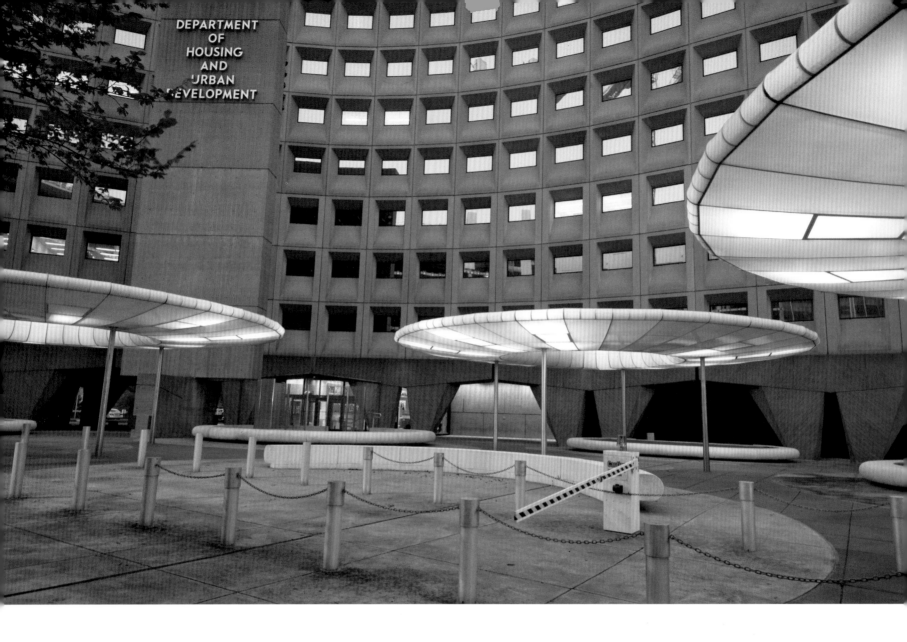

The Department of Housing and Urban Development's goal is increasing home ownership and supporting community development. The stunning "flying saucers" in the plaza at the front of the building are a Washington landmark.

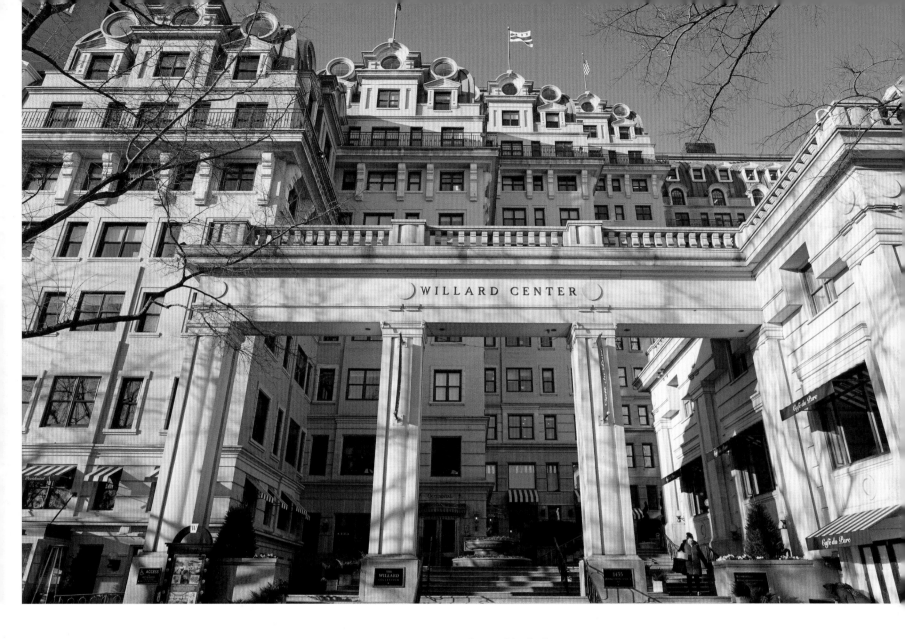

The Willard InterContinental Hotel on Pennsylvania Avenue is only two blocks from the White House. The hotel has accommodated guests since the early 19th century, among them President Lincoln, Charles Dickens, Harry Houdini and Martin Luther King Jr., who wrote his "I Have a Dream" speech in a room here.

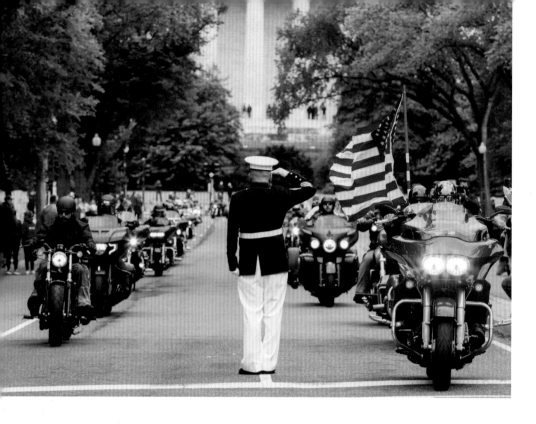

The Saluting Marine salutes passing demonstrators riding in the Rolling to Remember Memorial Day parade, which raises awareness of veterans' issues and honors fallen members of all branches of the military.

(Right) A platoon from the United States Marine Corps march in the Memorial Day parade wearing the blue and white dress uniform.

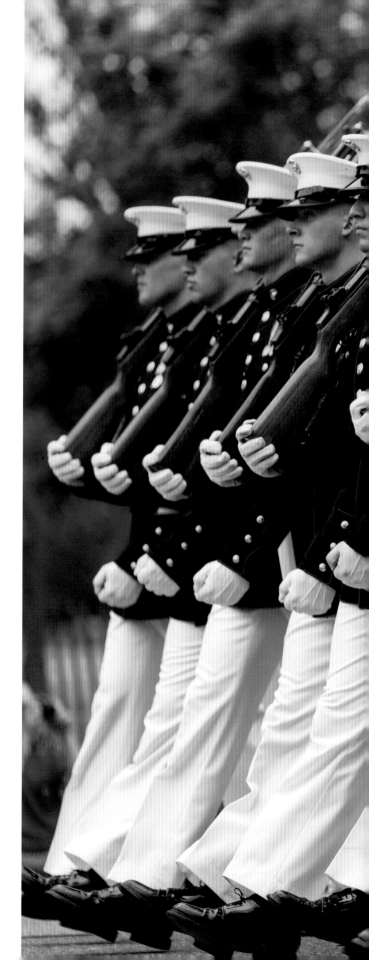

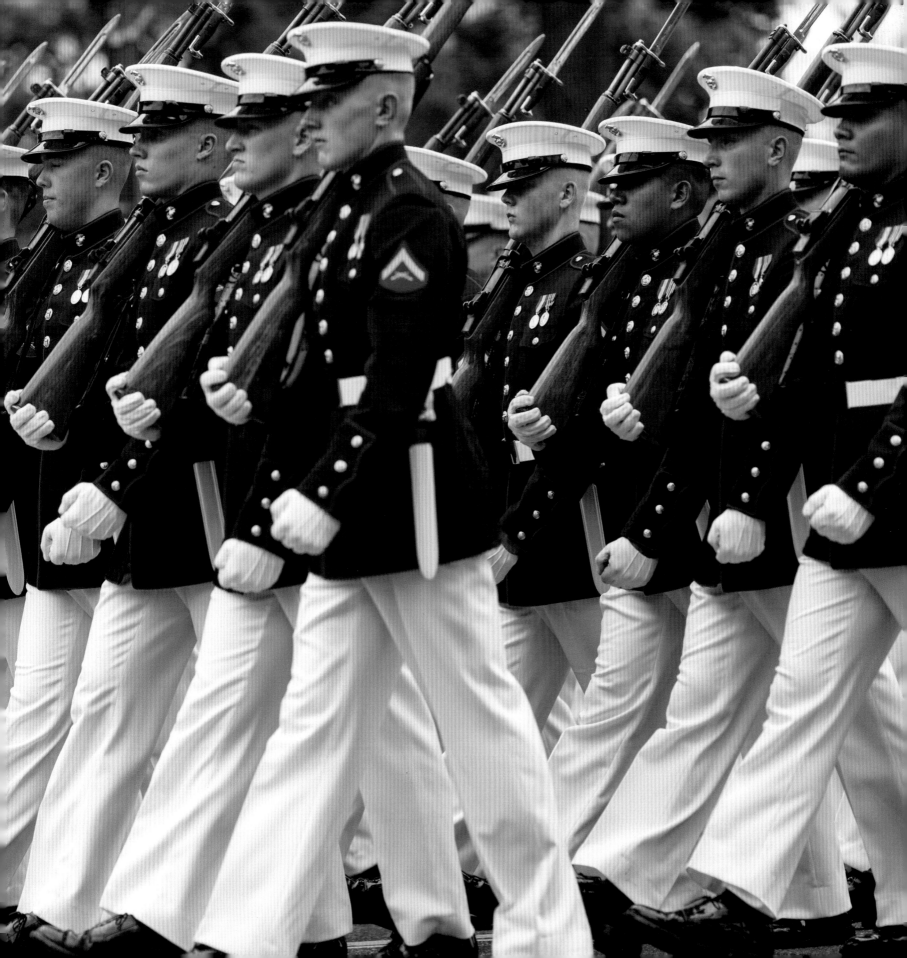

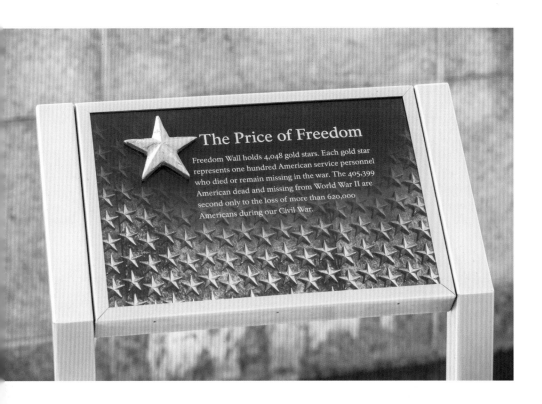

The National World War II Memorial in Washington consists of 56 17-foot-tall granite pillars that flank a central plaza and the Rainbow Pool. Each pillar represents a state or territory that sent citizens to fight in conflict. The 7.4-acre memorial also includes fountains and a wall covered with 4,000 gold stars, each star representing 100 servicemen who died in the war.

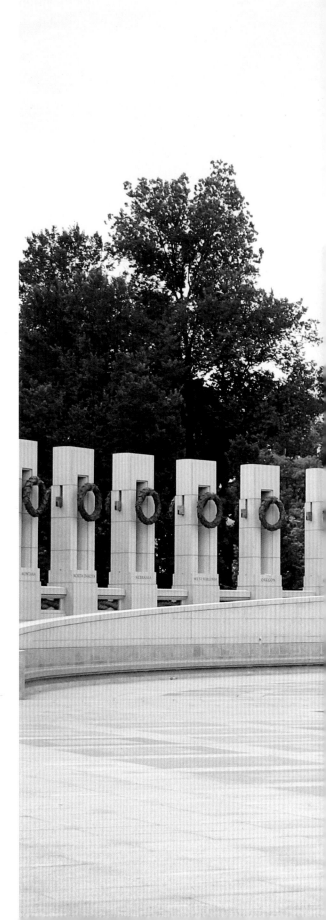

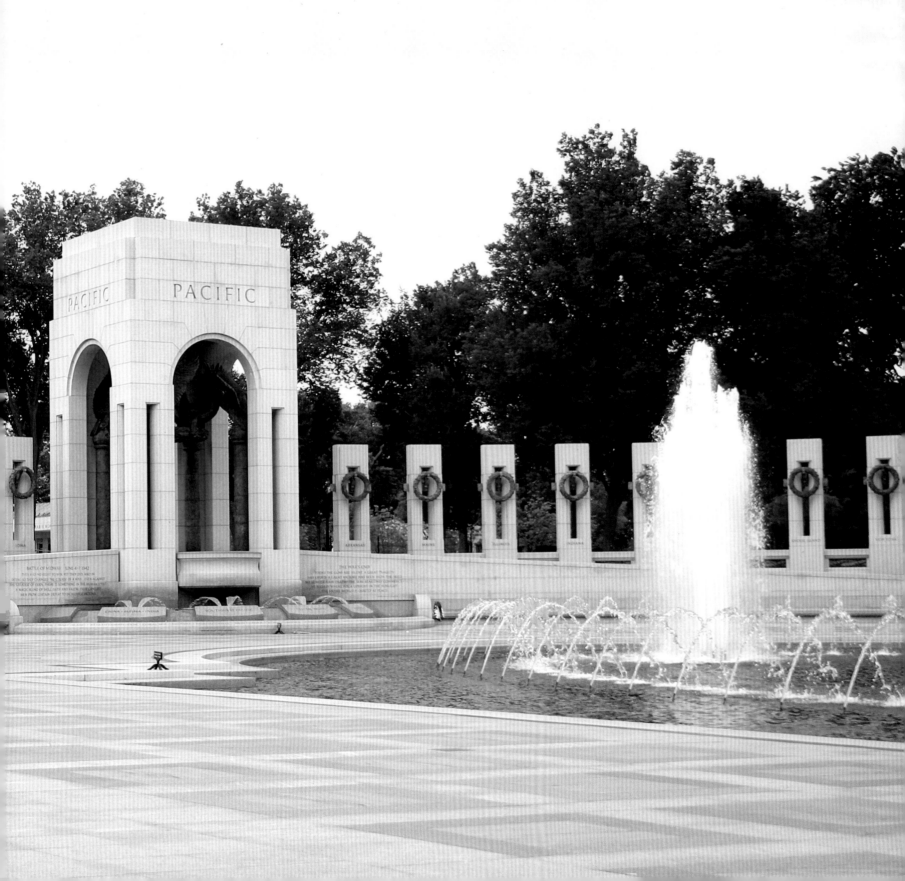

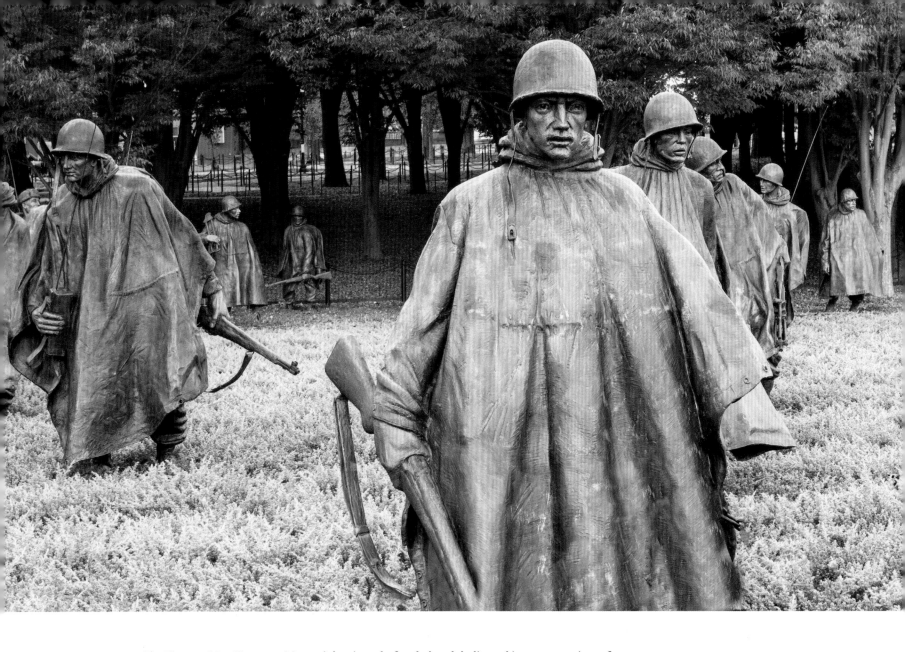

The Korean War Veterans Memorial, privately funded and dedicated in 1995, consists of a circular Pool of Remembrance and Field of Service studded with 19 lifelike statues of infantrymen on the march. More than 54,000 American servicemen died in the Korean War between 1950 and 1953.

(Right) The U.S. Marine Corps War Memorial, commonly known as the Iwo Jima Memorial, is a massive bronze statue outside Arlington National Cemetery. Its design was inspired by Joe Rosenthal's famous photograph, *Raising of the Flag on Iwo Jima*, and is dedicated to all members of the Marine Corps who have died in defense of their country.

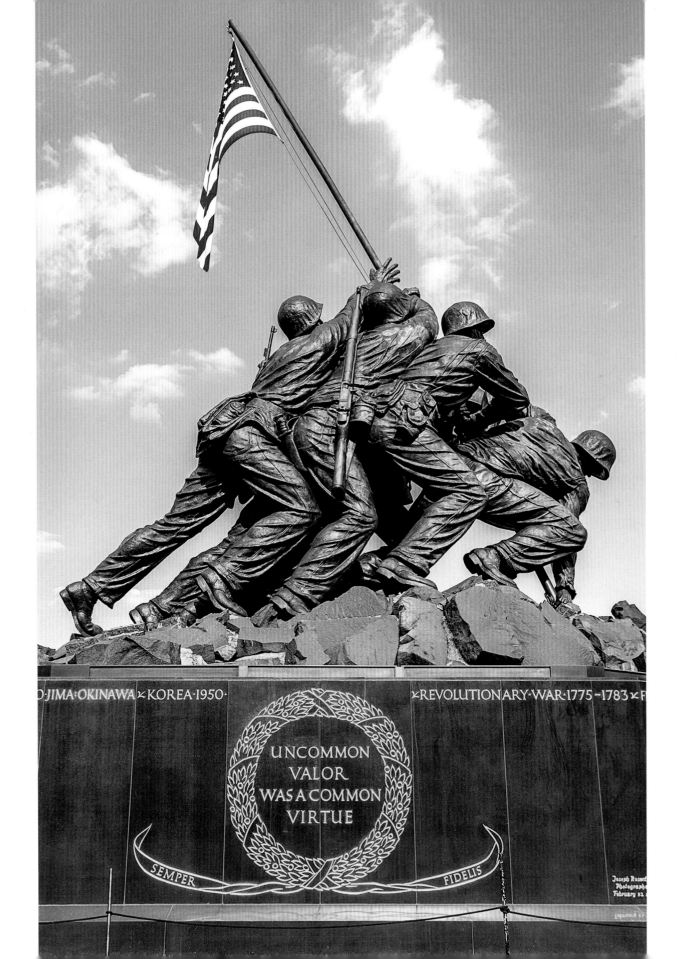

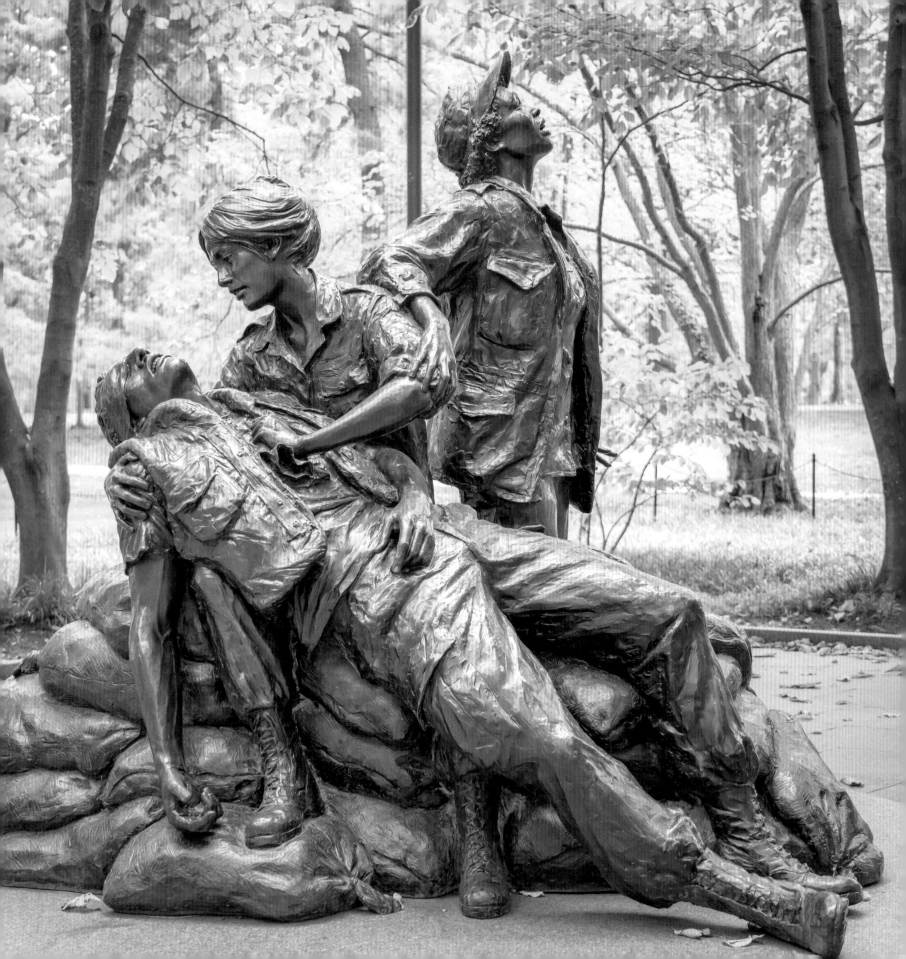

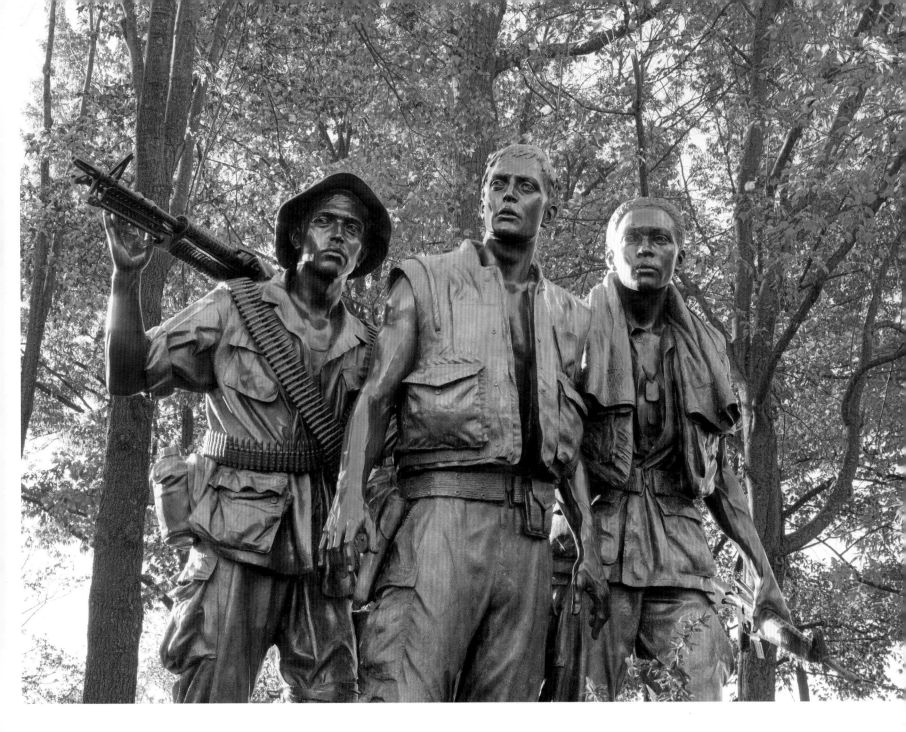

The Three Soldiers, a bronze statue and flagstaff, was unveiled on Veterans Day, 1984. Sculptor Frederick Hart described his sculpture of men serving in Vietnam as, "The contrast between the innocence of their youth and the weapons of war underscores the poignancy of their sacrifice."

(Left) The Vietnam Women's Memorial, dedicated in 1993, completes the Vietnam memorial complex. More than 10,000 civilian and military women served in Vietnam during the war. The Vietnam Women's Memorial was established not only to honor those women who served, but also to educate the American public about their service.

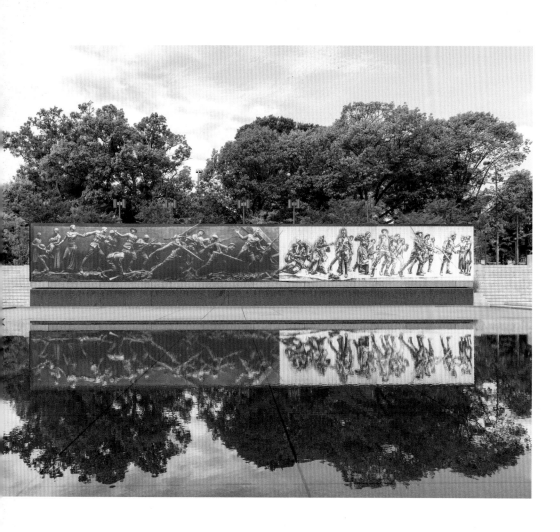

The beautiful World War I American Expeditionary Forces
Memorial in Pershing Park depicts the American experience in
its first European war.

(Right) One of the most poignant sights in Washington is the
Vietnam Veterans Memorial. Erected in 1982, its two black granite
walls, inscribed with the names of the men and women who died
in America's longest war, stretch into a V, one side pointing at the
Washington Monument, the other at the Lincoln Memorial.

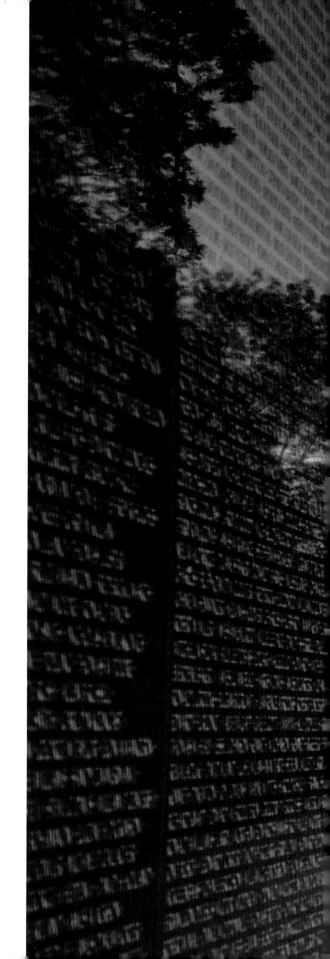

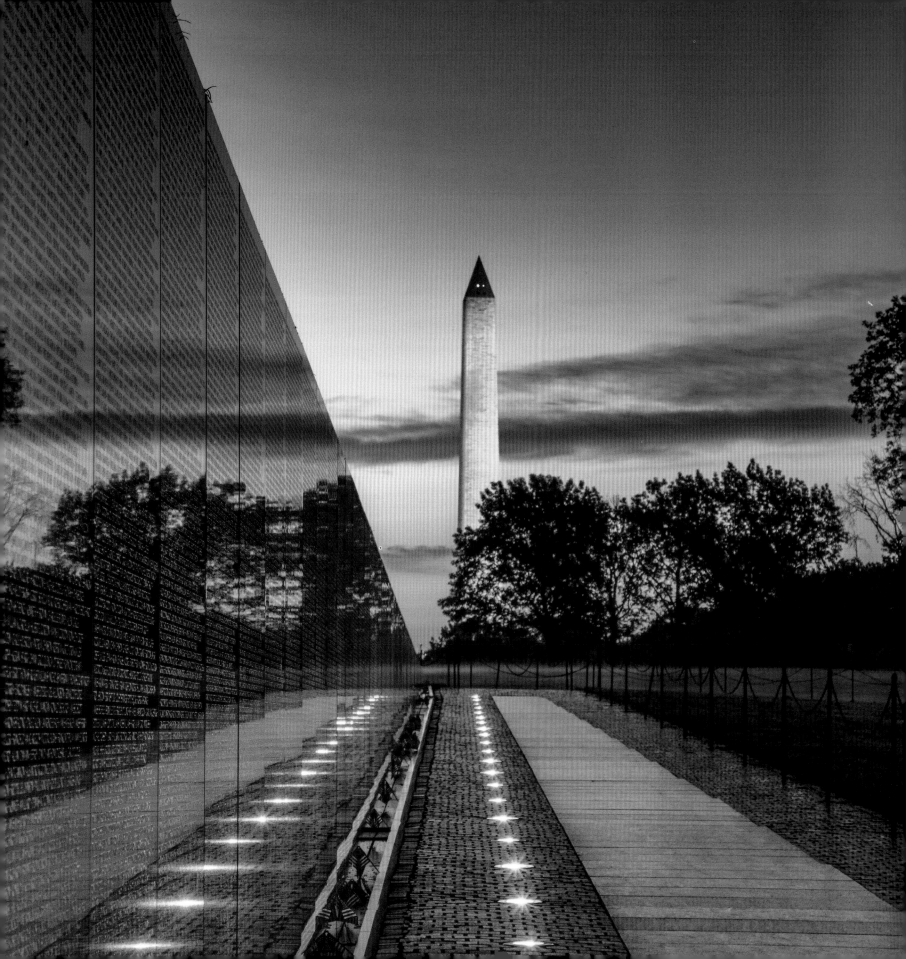

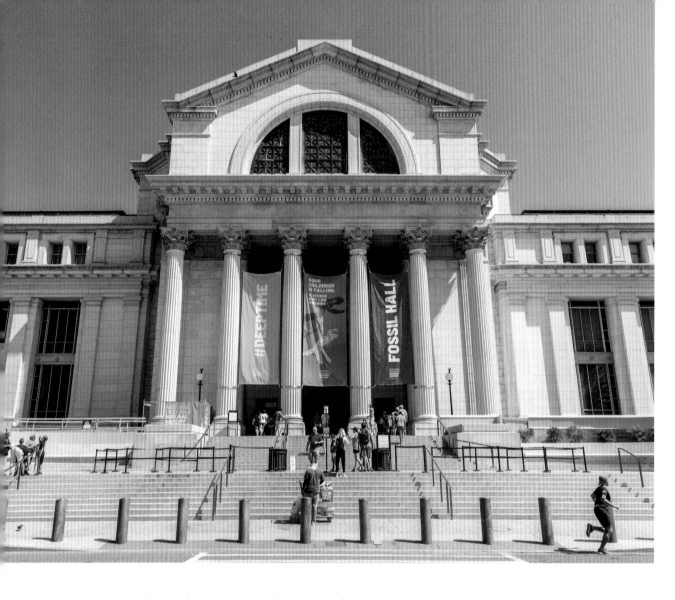

The Smithsonian National Museum of Natural History opened the doors here in 1910. Since that time, it has developed a treasure trove of objects and artifacts, containing everything from the Hope Diamond, to half a million dinosaur fossils, to a 24-foot-long giant squid. This massive, eight-ton African elephant (right) was 50 years old when it died in 1955. Its size was so remarkable that the hunter decided to donate it to the Smithsonian. Ever since, it has been proudly displayed beneath the rotunda.

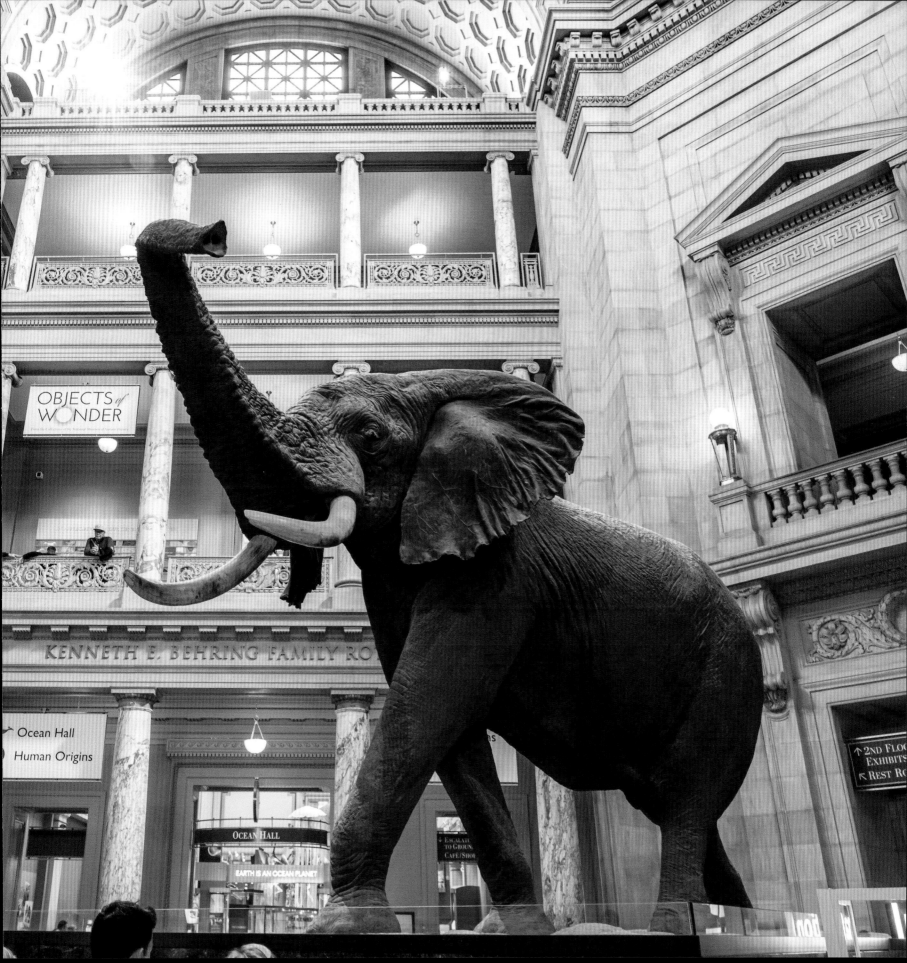

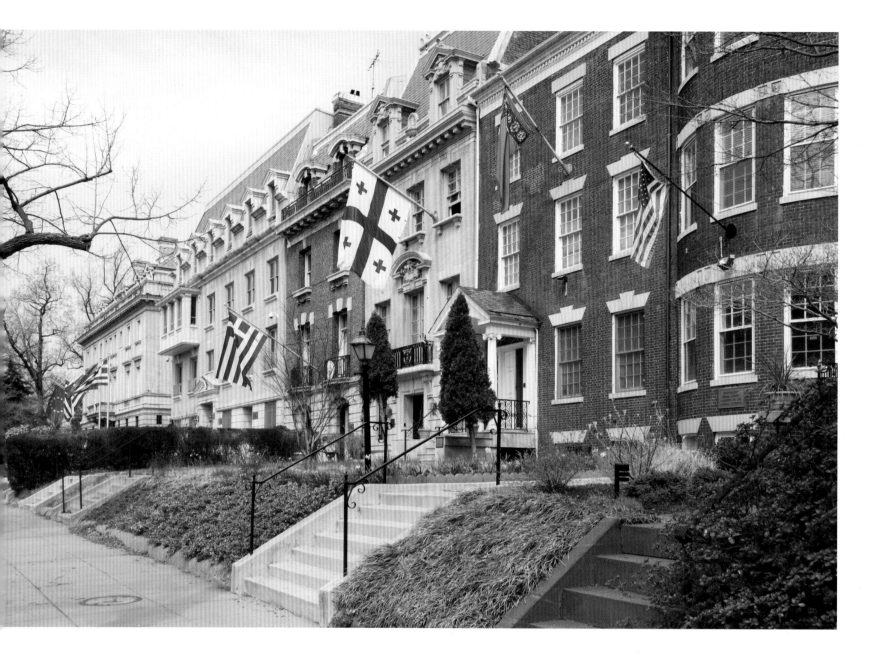

The Georgetown area in Washington, one of the district's most sought-after neighborhoods, is filled with beautiful and well-maintained row houses like these. Many have been converted to embassies, and the stretch of buildings along Massachusetts Avenue is now often referred to as Embassy Row.

(Right) The historic architecture of these beautiful Victorian townhouses on Logan Circle has been preserved to this day.

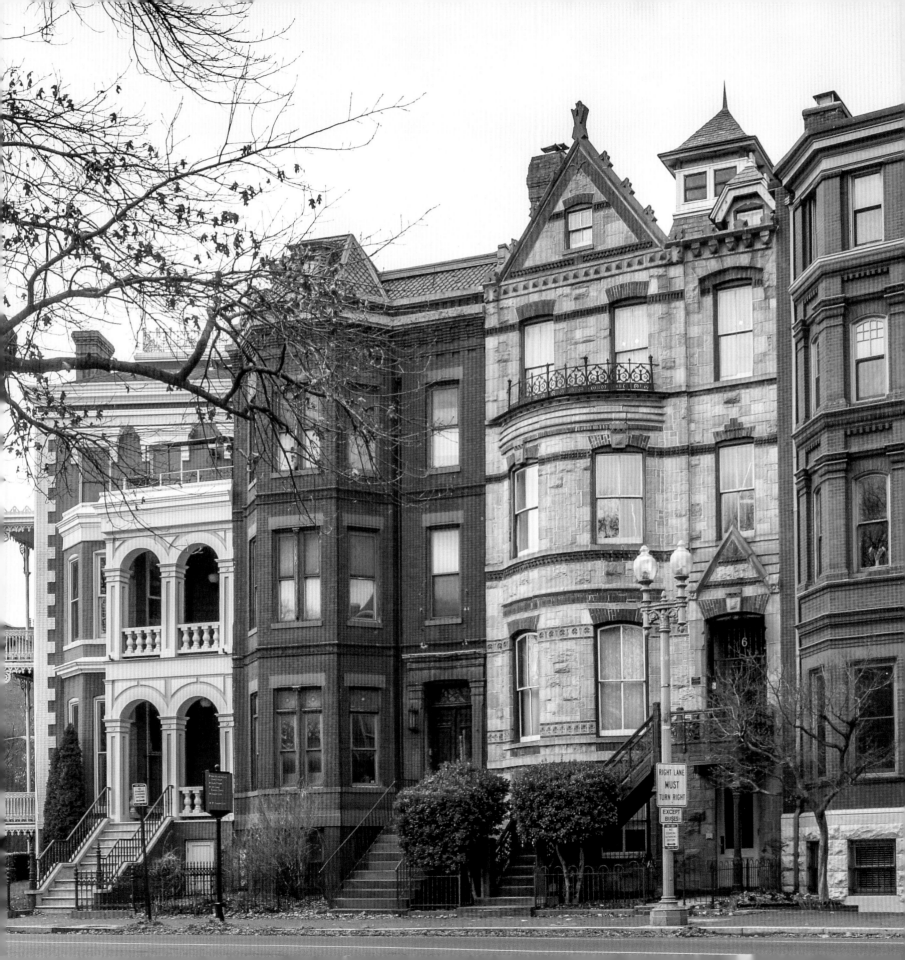

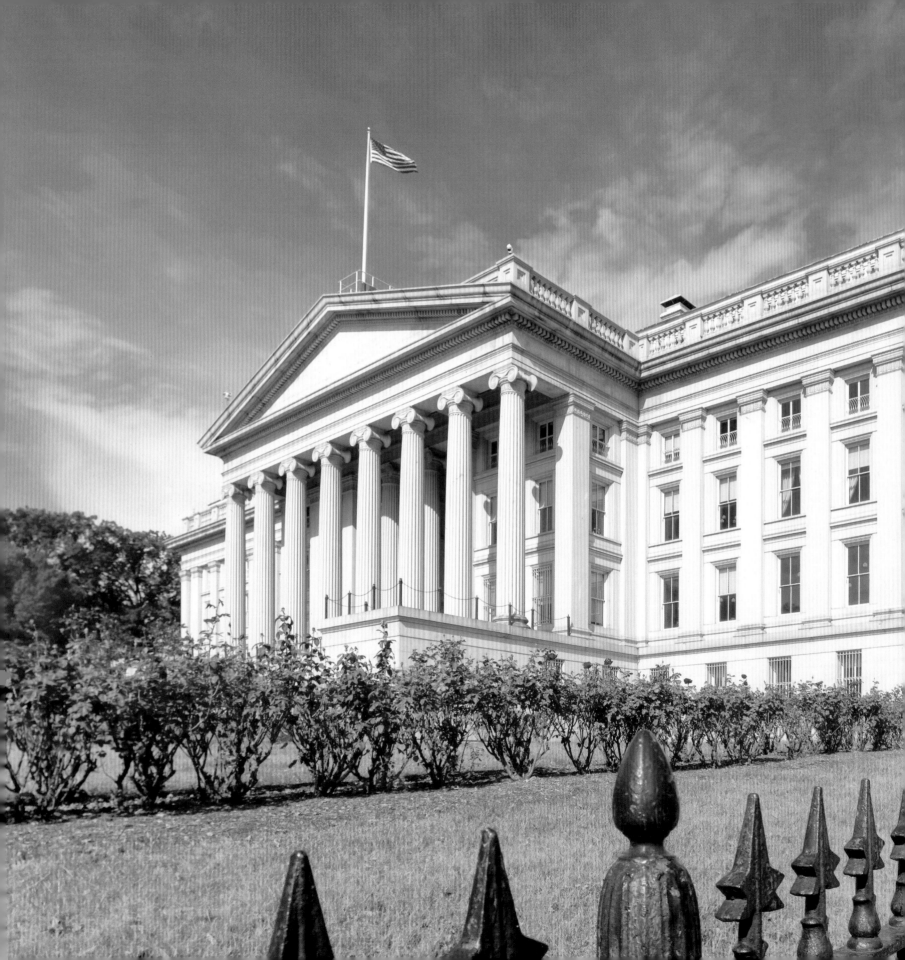

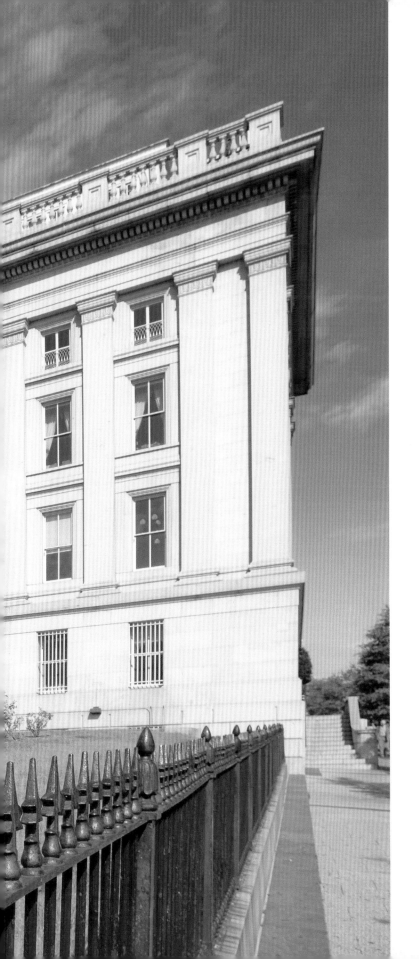

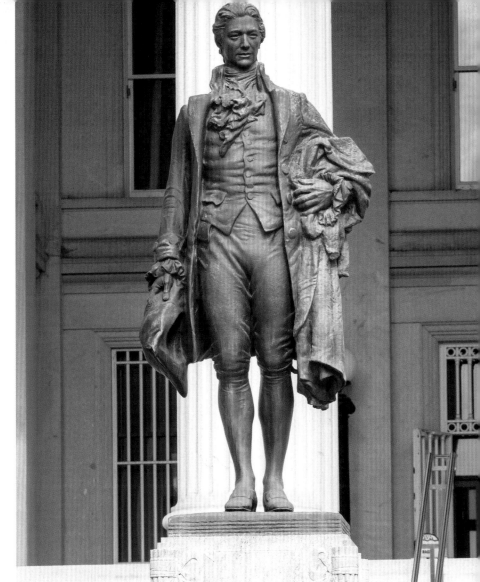

The beautiful Treasury Building is the headquarters of the United States Department of the Treasury. A statue of Alexander Hamilton, the first Secretary of the Treasury, stands outside the entrance to the building.

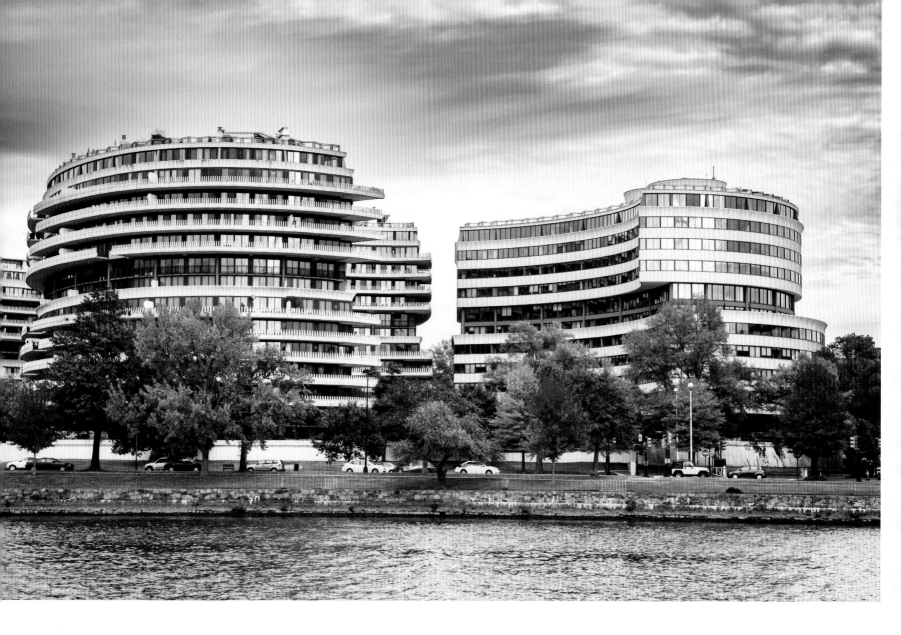

The Watergate Complex, a group of five large residential buildings next to the Kennedy Center for the Performing Arts, is famous as the site of the 1970s scandal that led to the resignation of President Richard Nixon.

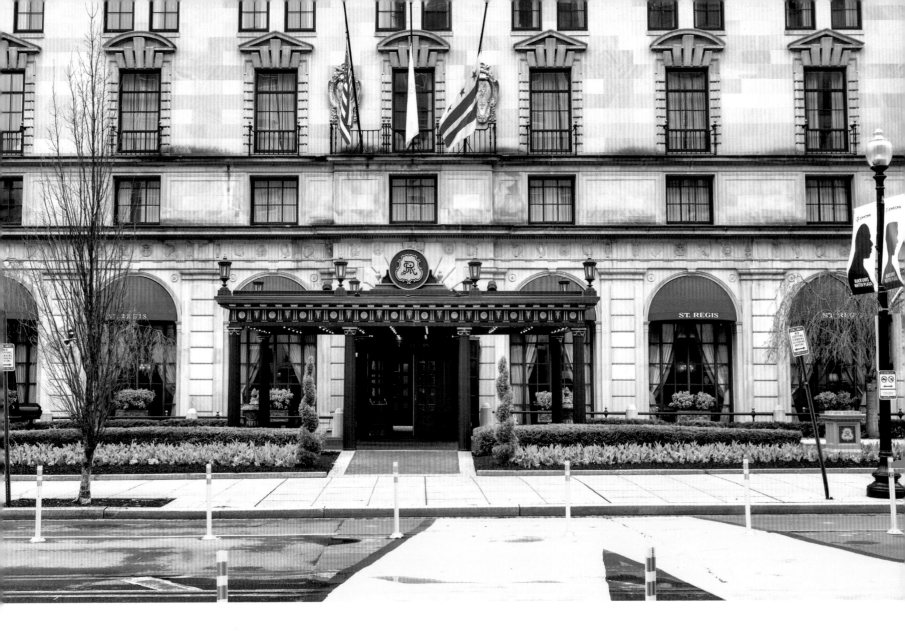

Opened by President Calvin Coolidge in 1926, the historic St. Regis Hotel has hosted most of the American presidents as well as royalty and prime ministers. Built in the Beaux Arts style and only a few blocks from the White House, the hotel is one of the most beautiful in the city.

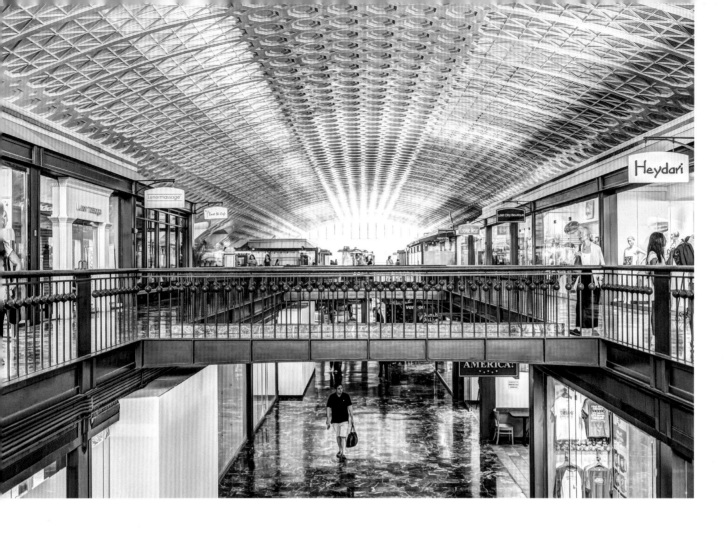

At the time it opened in 1907, Union Station was the largest train station in the world. Seventy pounds of 22-karat gold leaf were used to adorn its barrel-vaulted ceilings. The station's white granite had a major influence on Washington's monumental architecture. Union Station still functions as a terminal, but many of the 32 million people who visit it each year come to admire the Beaux Arts architectural style or enjoy the many shops and restaurants (above) found here.

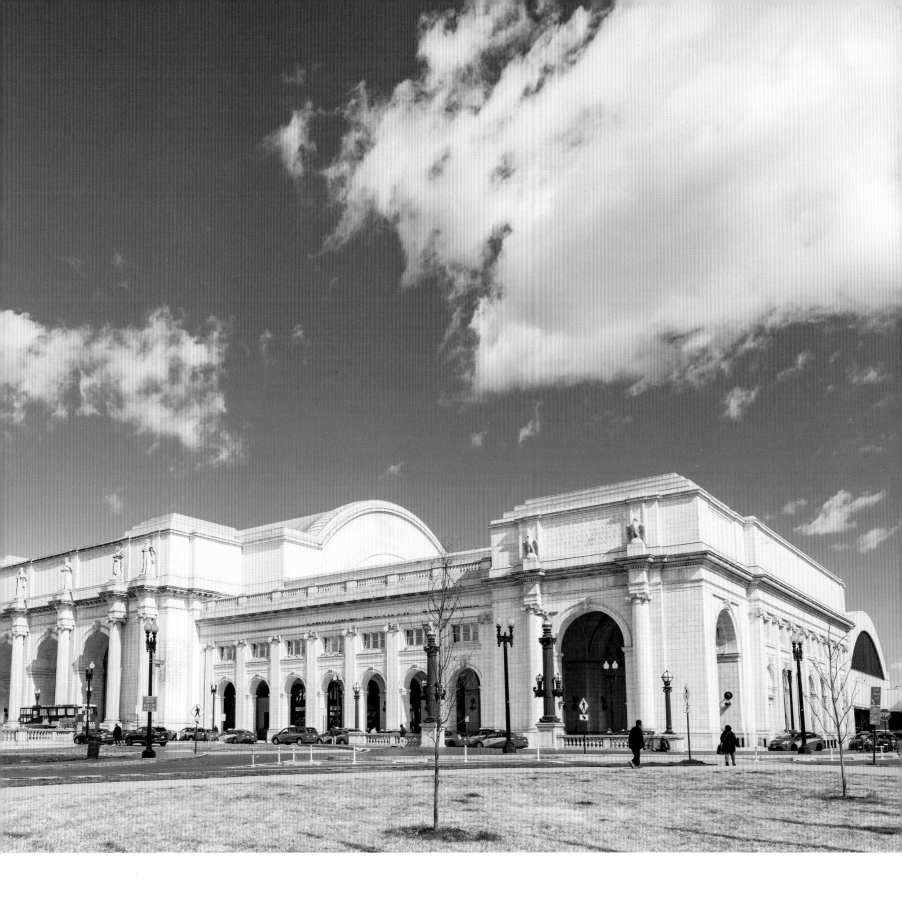

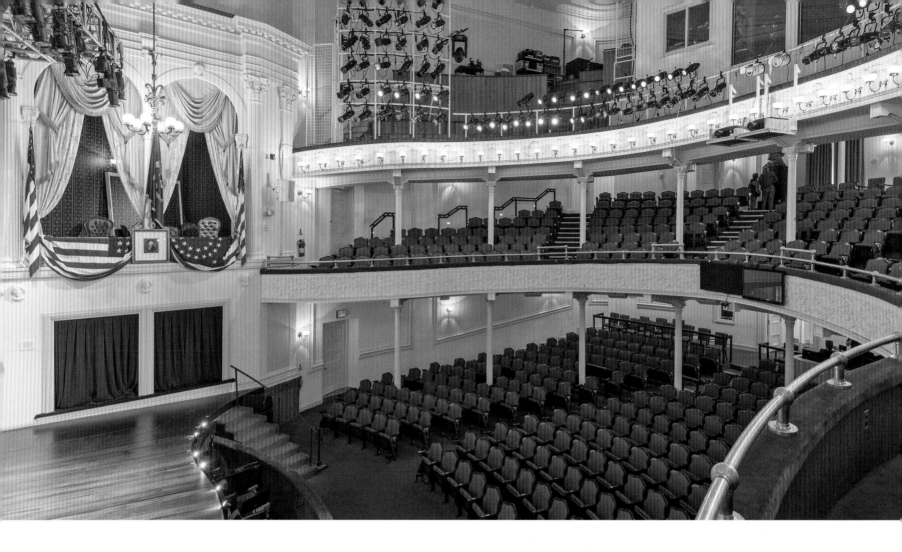

The beautifully restored stage and auditorium of Ford's Theatre still serves as a center for the performing arts in Washington, DC. The theater is infamous as the site of President Abraham Lincoln's assassination by John Wilkes Booth in 1865.

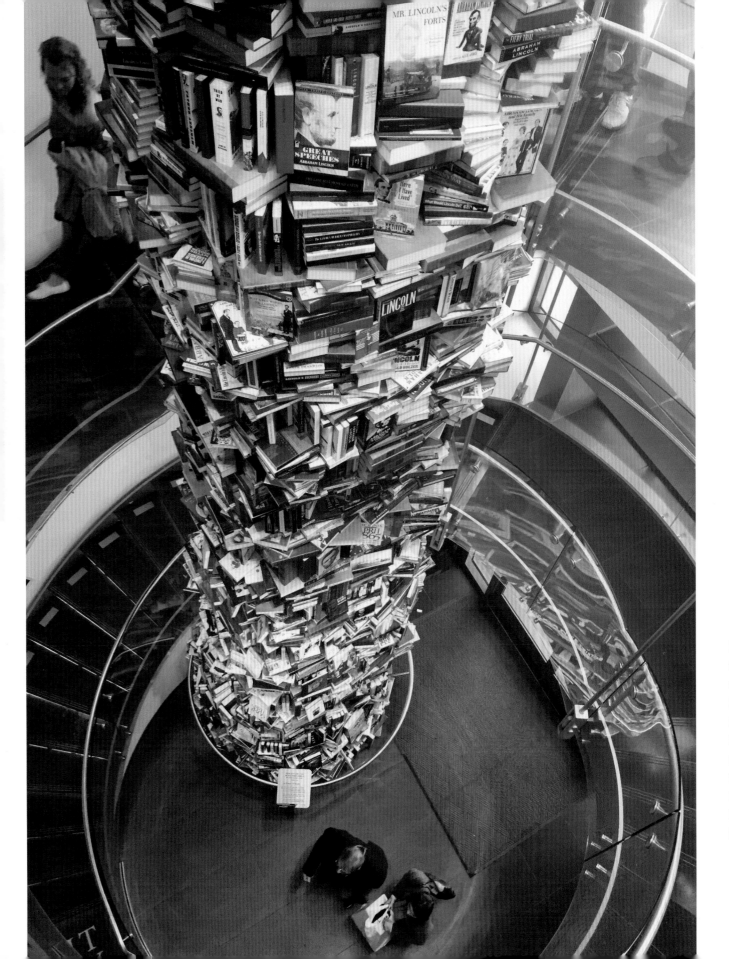

Looking down from the circular staircase at the "Stack" at the Ford's Theatre Center for Education and Leadership. The "Stack" represents the more than 15,000 books that have been written about President Abraham Lincoln.

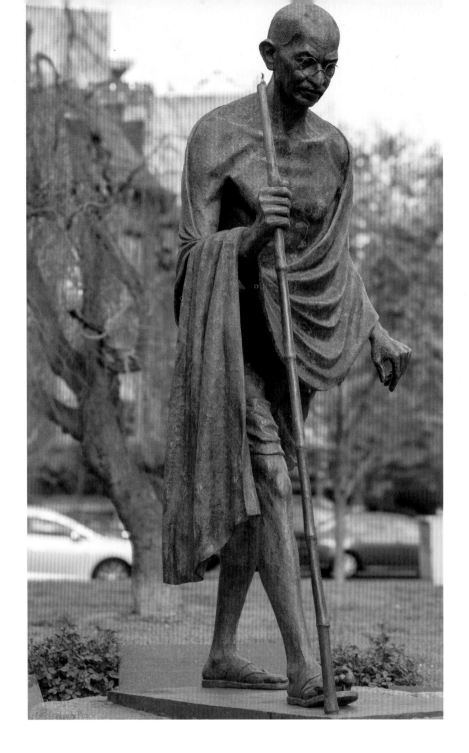

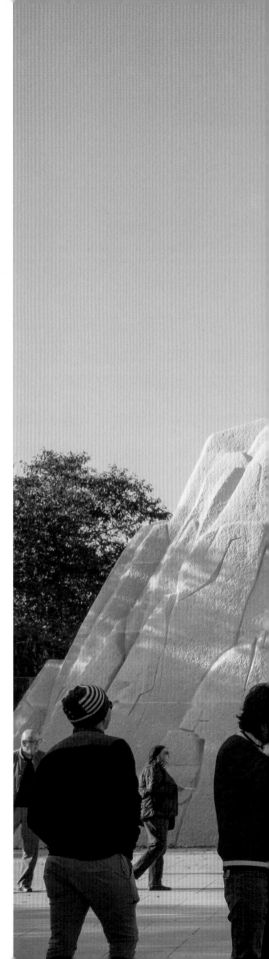

This statue in front of the Embassy of India depicts Mahatma Gandhi, a pioneer of the idea of resistance to tyranny through mass peaceful civil disobedience. The Martin Luther King, Jr. Memorial (right) in West Potomac Park includes the Stone of Hope, a granite statue inspired by a line from King's "I Have a Dream" speech: "Out of the mountain of despair, a stone of hope."

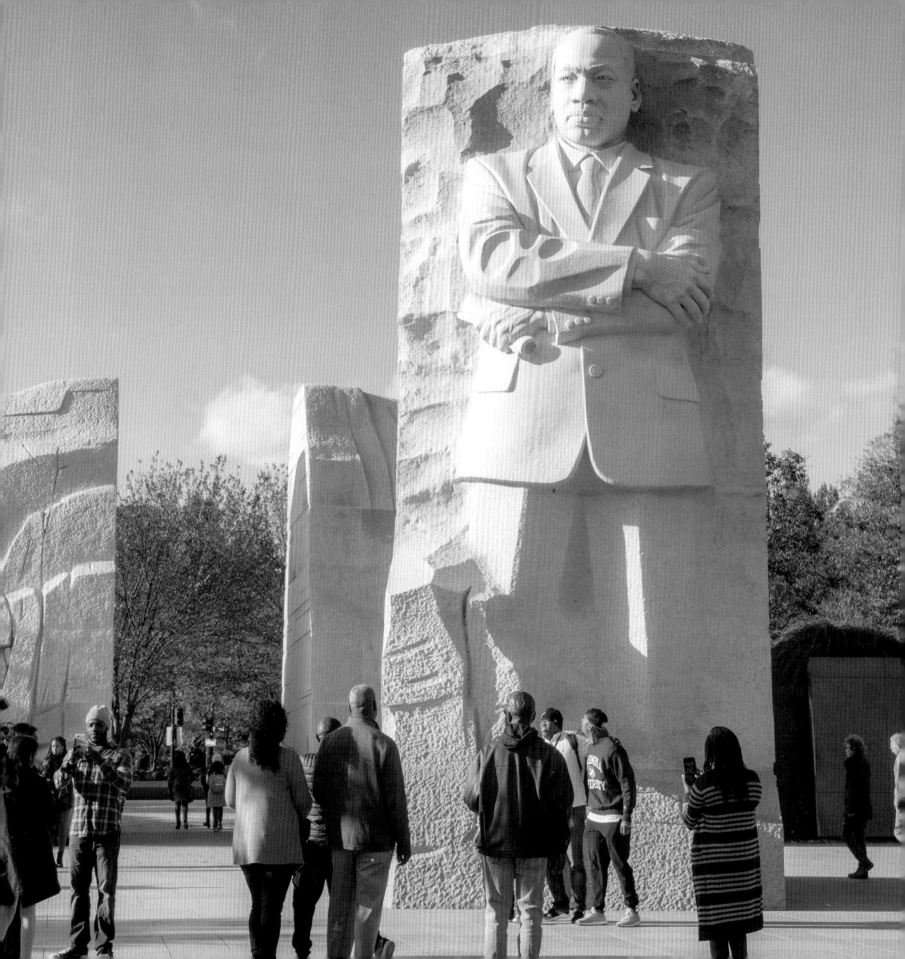

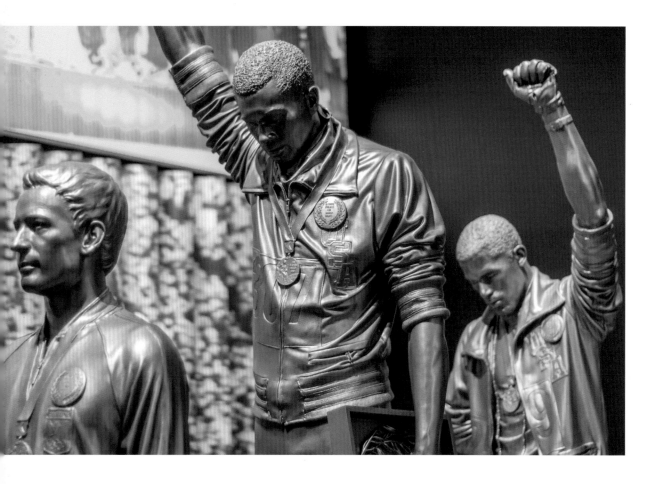

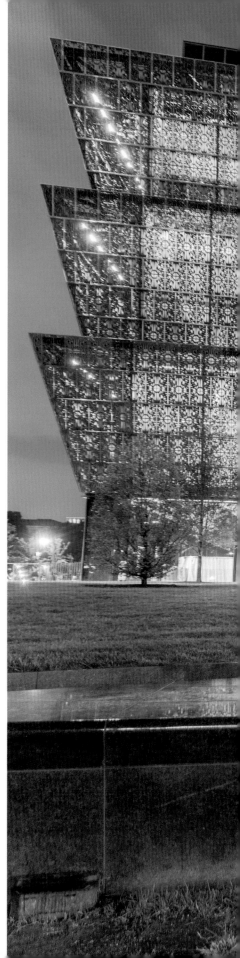

A statue of American track and field stars Tommie Smith and John Carlos raising gloved fists during the medal ceremony at the 1968 Summer Olympics is part of the Sports Galleries at the National Museum of African American History and Culture.

(Right) The beautiful National Museum of African American History and Culture, on the National Mall, was opened by President Barack Obama in 2016. Part of the Smithsonian Institution, the museum celebrates the struggles, triumphs and achievements of the African American experience in the United States. The Washington Monument stands in the background.

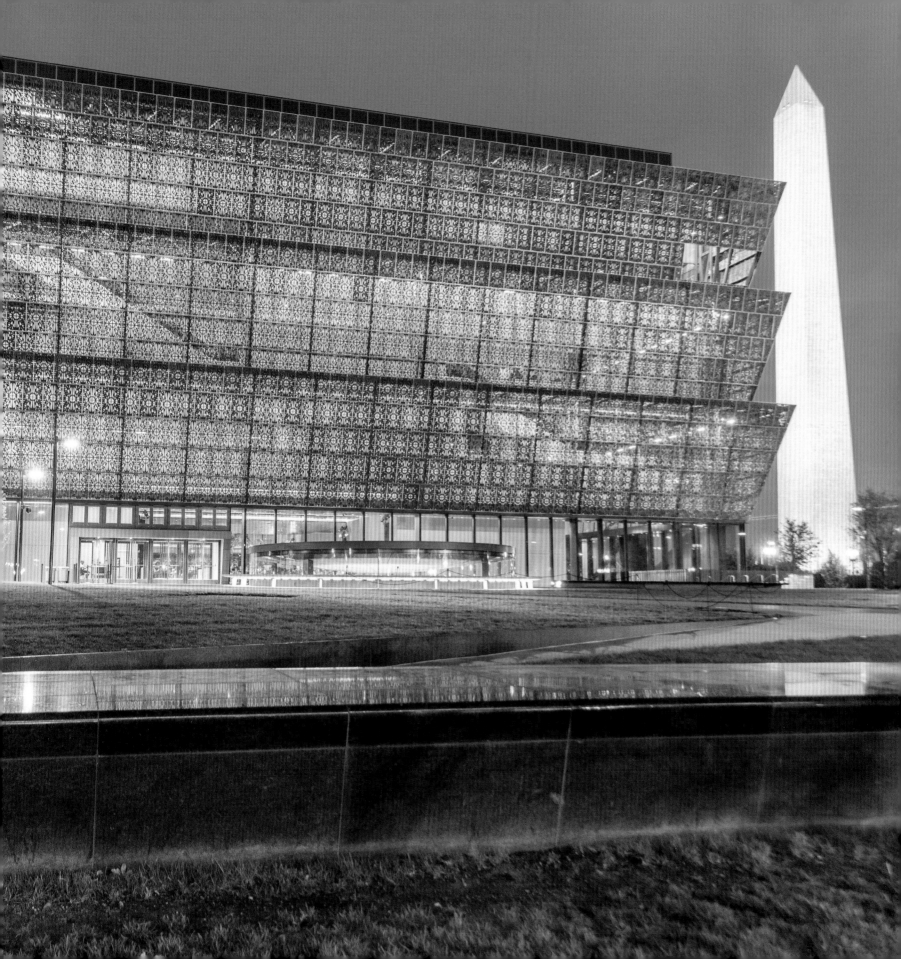

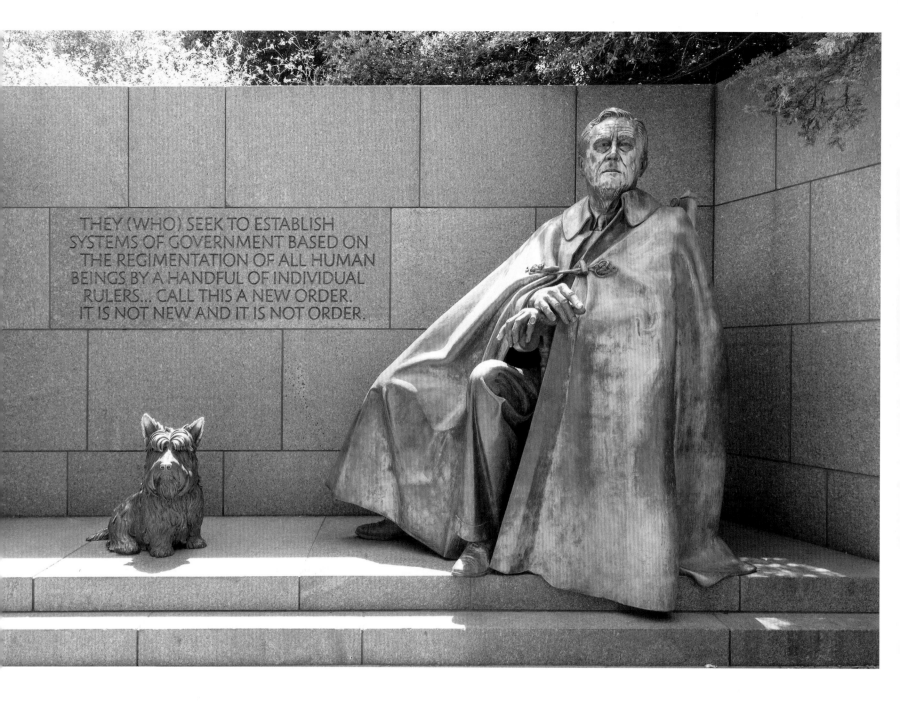

THEY (WHO) SEEK TO ESTABLISH
SYSTEMS OF GOVERNMENT BASED ON
THE REGIMENTATION OF ALL HUMAN
BEINGS BY A HANDFUL OF INDIVIDUAL
RULERS... CALL THIS A NEW ORDER.
IT IS NOT NEW AND IT IS NOT ORDER.

The Franklin Delano Roosevelt Memorial is located on the western edge of the Tidal Basin. This statue of President Roosevelt with his dog, Fala, is part of a series of four outdoor rooms that depict FDR and his years as president.

(Right) This bronze statue by Robert Berks depicts Albert Einstein holding a paper on which is written his famous $E=mc^2$ equation. Erected in 1979, it sits on the grounds of the National Academy of Sciences.

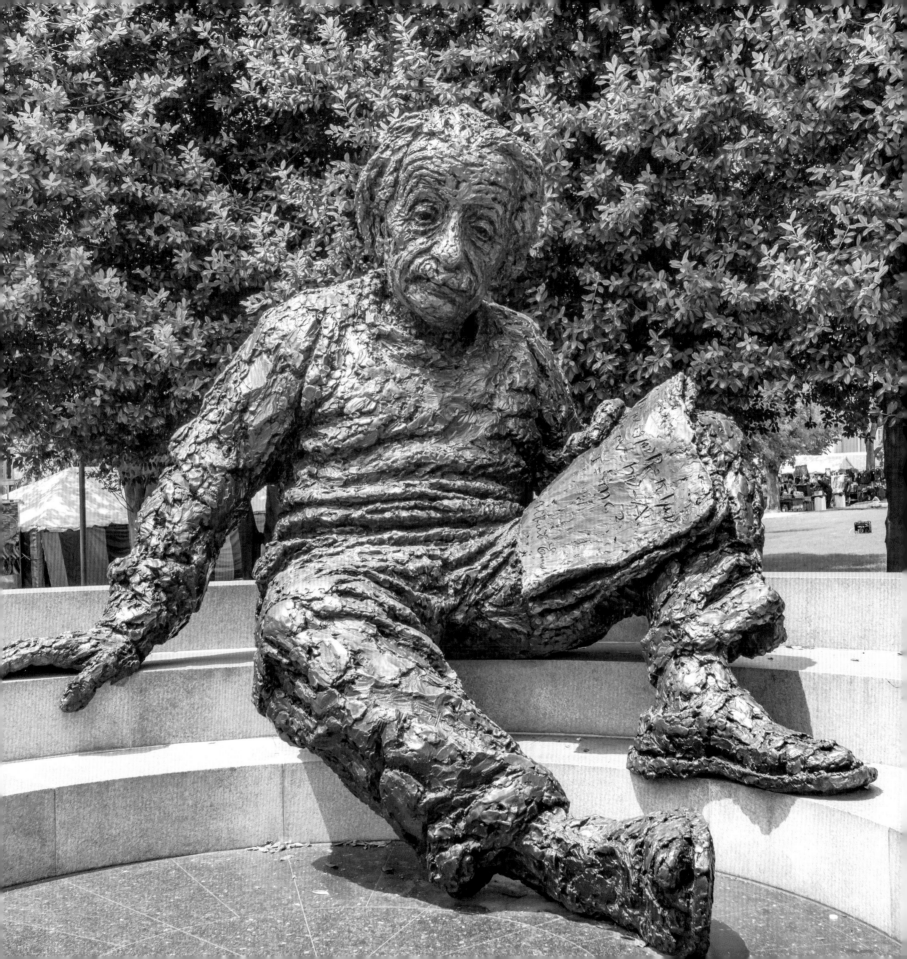

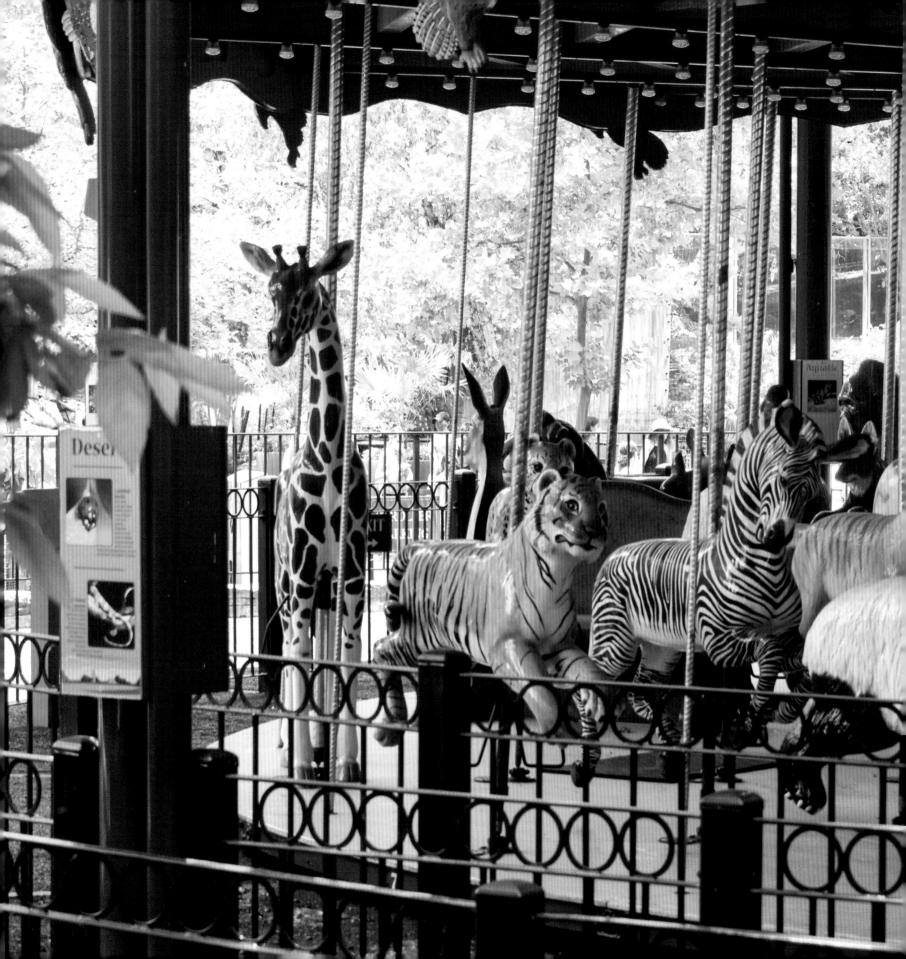

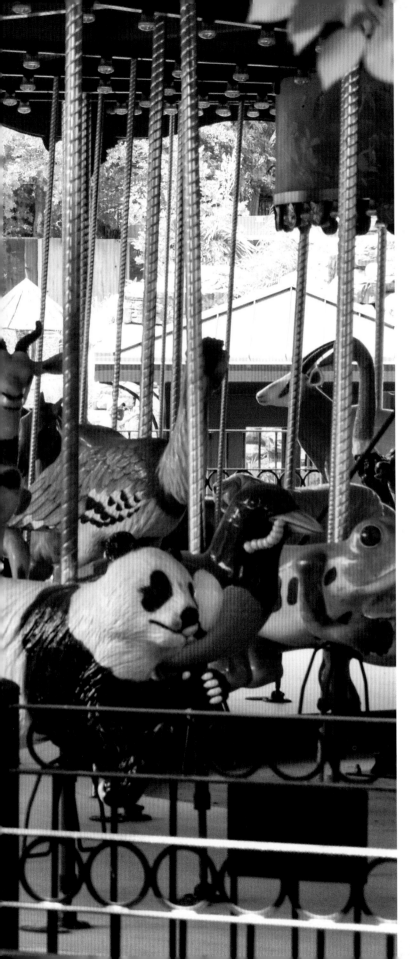

The National Zoological Park is part of the Smithsonian Institution. Its mission is to "provide engaging experiences with animals and create and share knowledge to save wildlife and habitats." The Rock Creek Park location covers 163 acres with hundreds of species of trees, shrubs and herbaceous plants. The Speedwell Foundation Conservation Carousel (left) is a major attraction for young visitors.

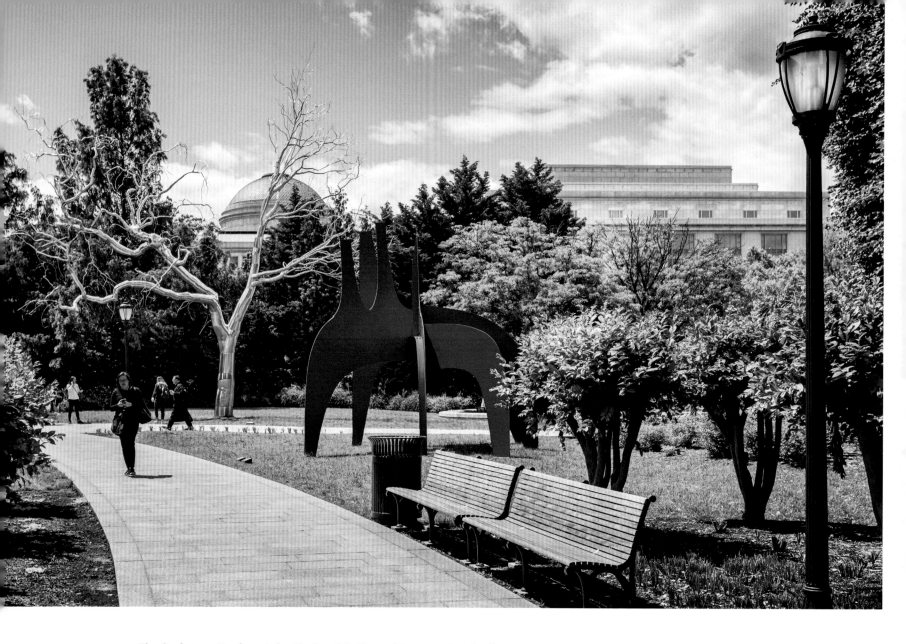

The Sculpture Garden at the National Gallery of Art contains the famous
Alexander Calder steel sculpture *Cheval Rouge* (Red Horse) as well as many
other famous pieces, making it a favorite outdoor destination for art lovers.

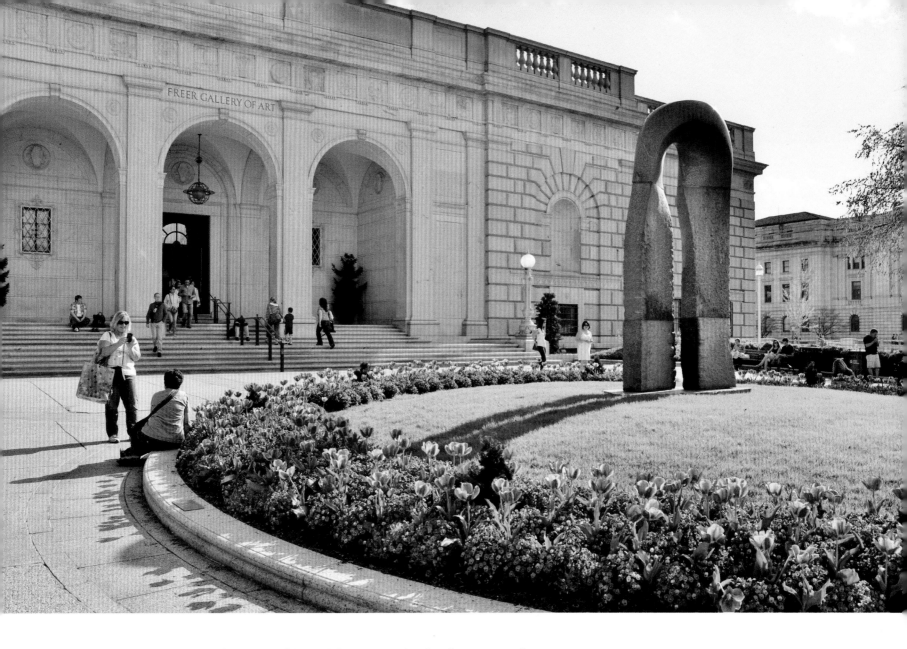

The Freer Gallery of Art, part of the Smithsonian Institution, focuses on Asian Art. The collection is one of the largest in the world and contains more than 26,000 objects created over 6,000 years. There is also a significant collection of American art, especially works by James McNeill Whistler.

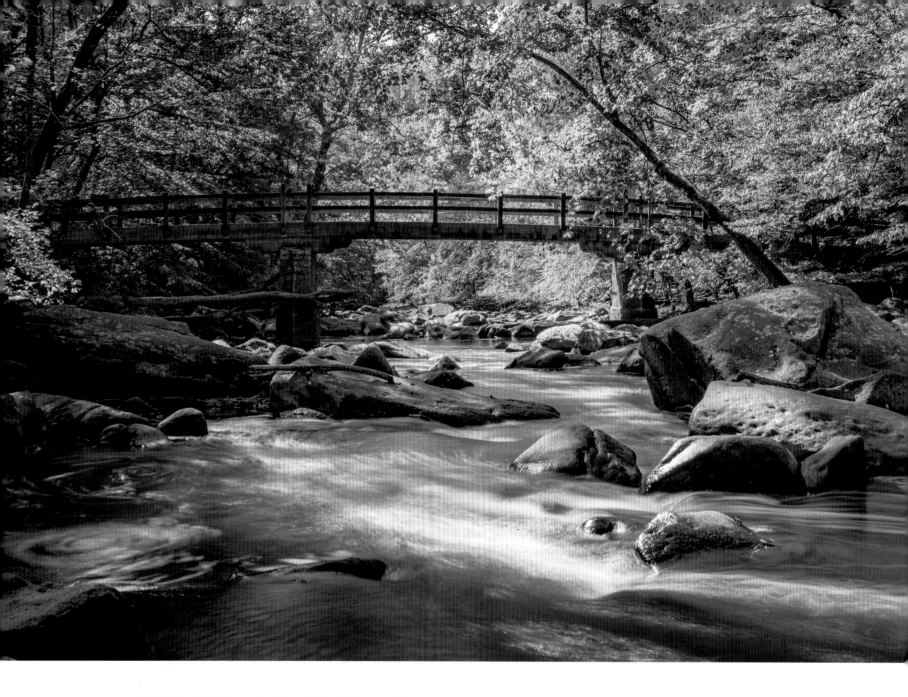

Rock Creek Park, created by an Act of Congress in 1890, covers over 1,700 acres along Rock Creek in Washington, DC. More than 2 million people visit the park each year. Rapids Bridge (above) and the Peirce Mill (right), built in 1829 and used to grind corn, wheat and rye until 1897, are major attractions.

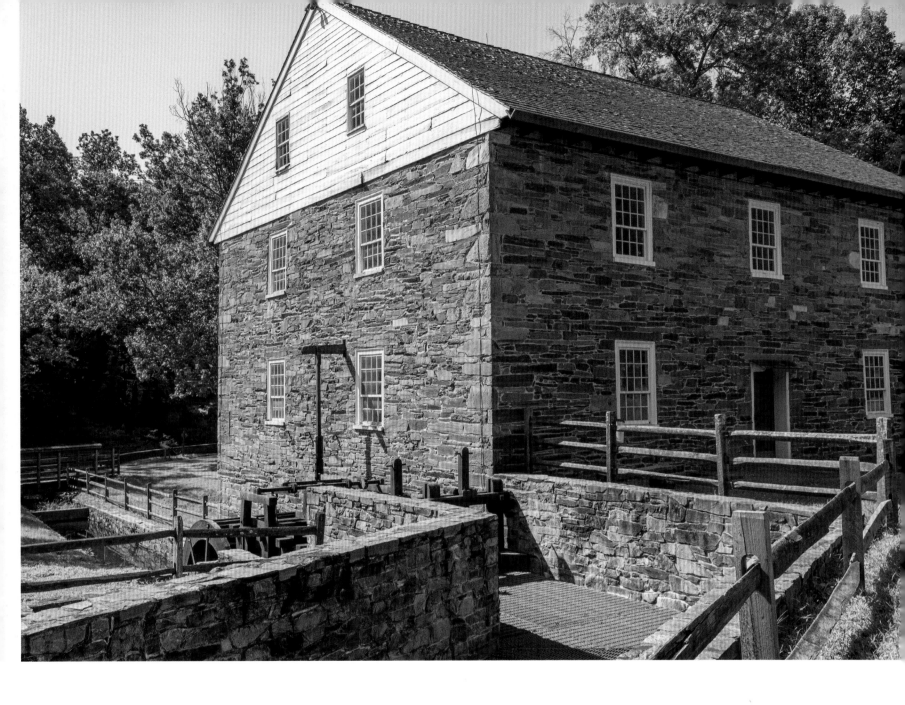

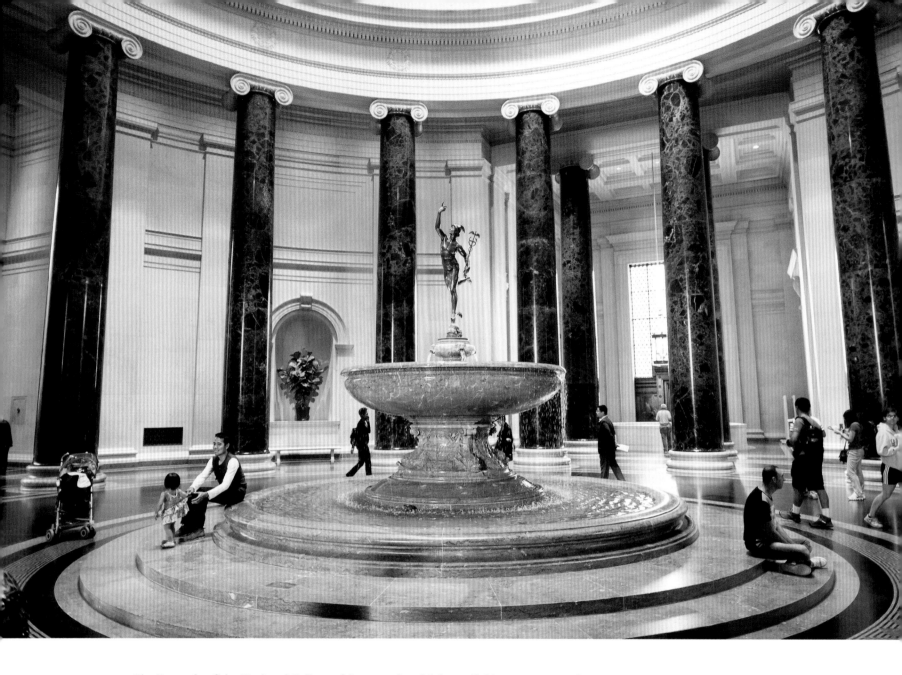

The Rotunda of the National Gallery of Art contains this beautiful bronze statue of Mercury atop a marble fountain. Mercury points towards Mount Olympus as a source of knowledge, truth, peace and comfort, and serves as a symbol of the purposes of the gallery.

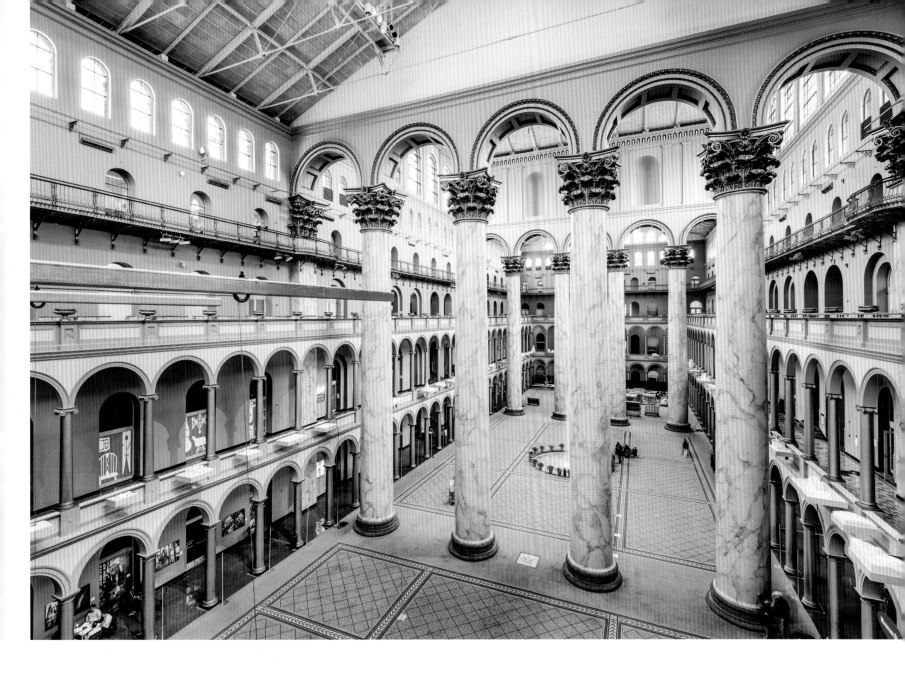

The Great Hall of the National Building Museum, with its lofty pillars and galleries, was completed in 1887. Once the home of the Pension Bureau, it is now a museum of architecture and design.

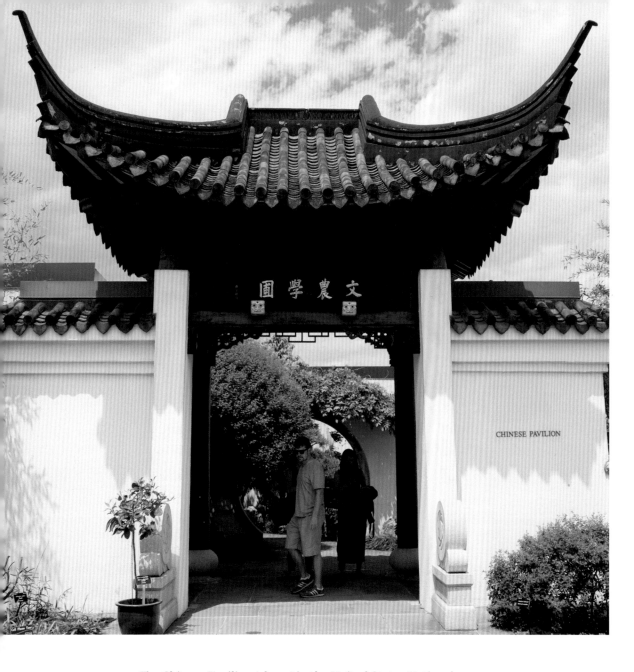

The Chinese Pavilion (above) in the United States National
Arboretum is a popular attraction. Established in 1927, the
arboretum covers 446 acres northeast of the Capitol Building
and is especially beautiful in the fall. It is the major research
center for the U.S. Department of Agriculture and attracts
about 500,000 visitors a year.

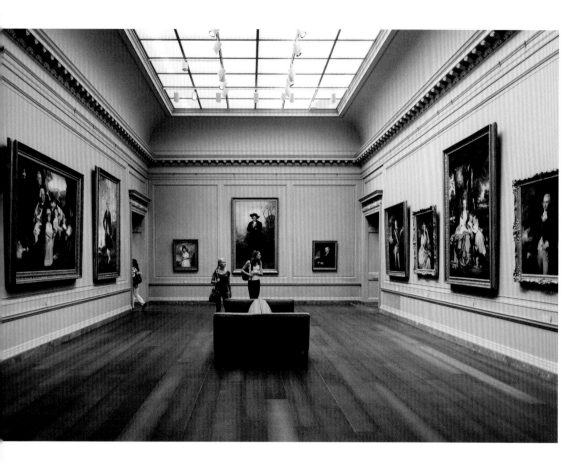

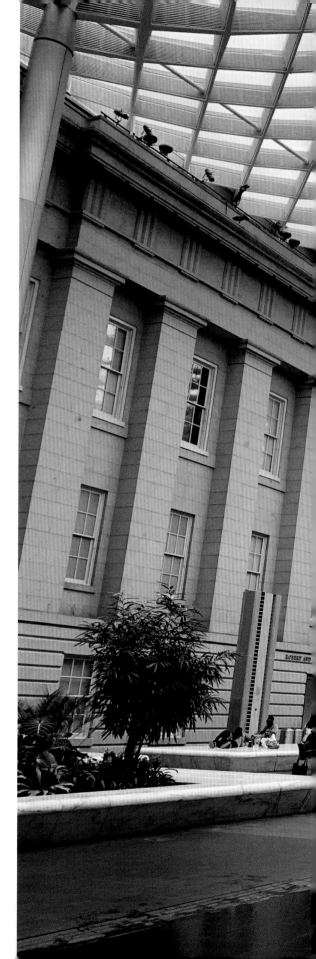

The Smithsonian National Portrait Gallery, housed in the beautiful old Patent Office Building, focuses on portraits of famous Americans. The elegant glass and steel roof of the enclosed Kogod Courtyard (right) seems to float over the classical Greek Revival building.

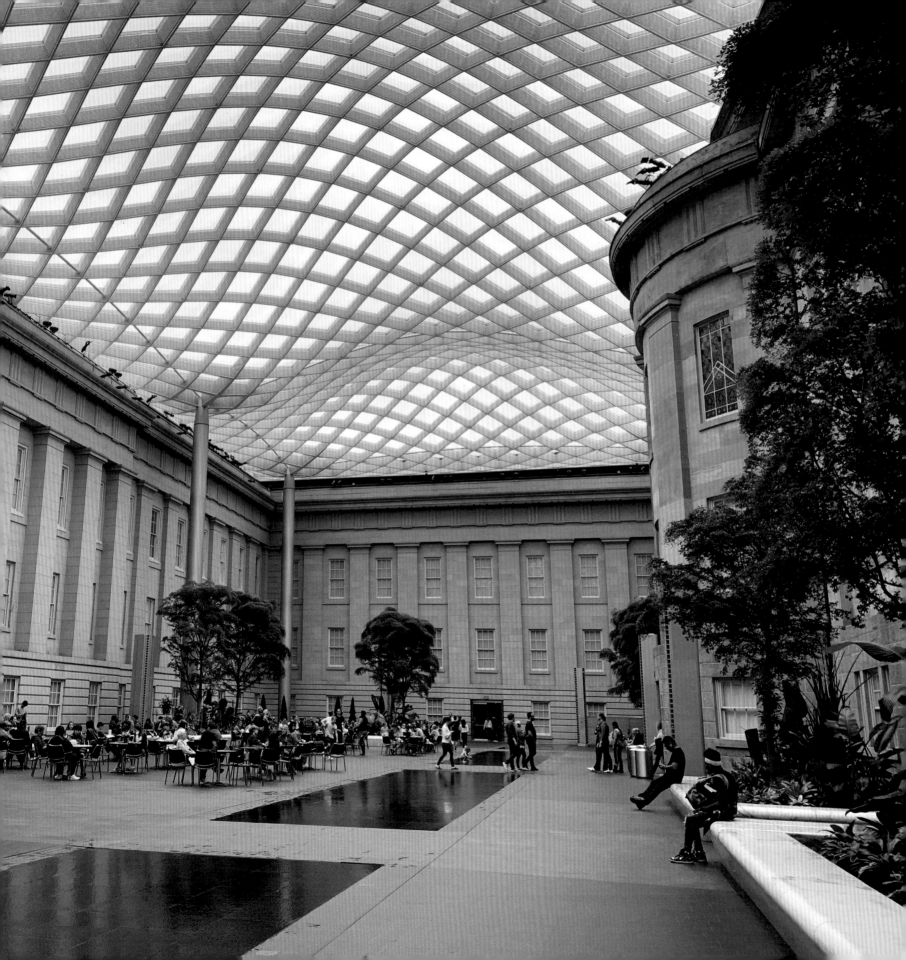

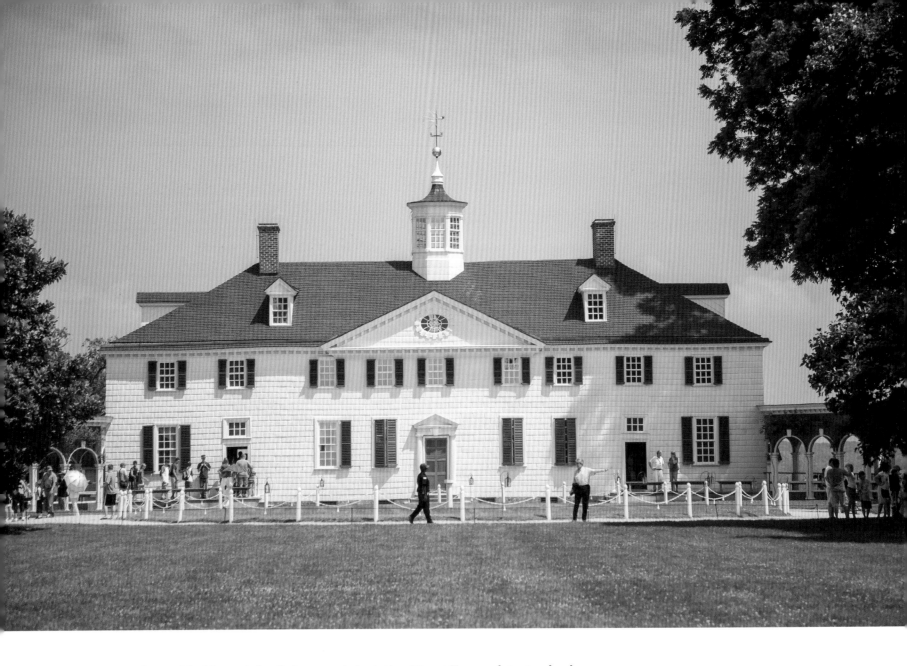

George Washington's family home and plantation, Mount Vernon, dates to a land grant received by his great-grandfather in 1674. It is located only 16 miles south of the capital. Today more than a million tourists visit each year to see the 18th-century mansion, as well as its plantation outbuildings, family tomb, gardens and farmland.

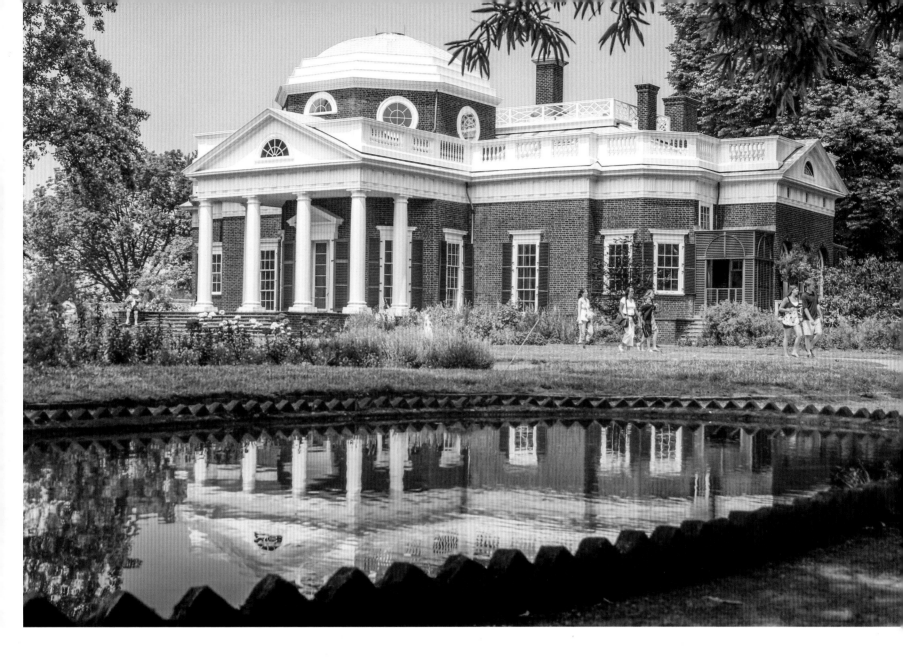

Thomas Jefferson, author of the Declaration of Independence and third president of the United States, designed and supervised the building of his house. The name Monticello derives from an Italian word meaning "little mountain." The house sits atop an 850-foot-high peak in Virginia, about 100 miles from Washington. It is a UNESCO World Heritage Site that receives more than 450,000 visits a year.

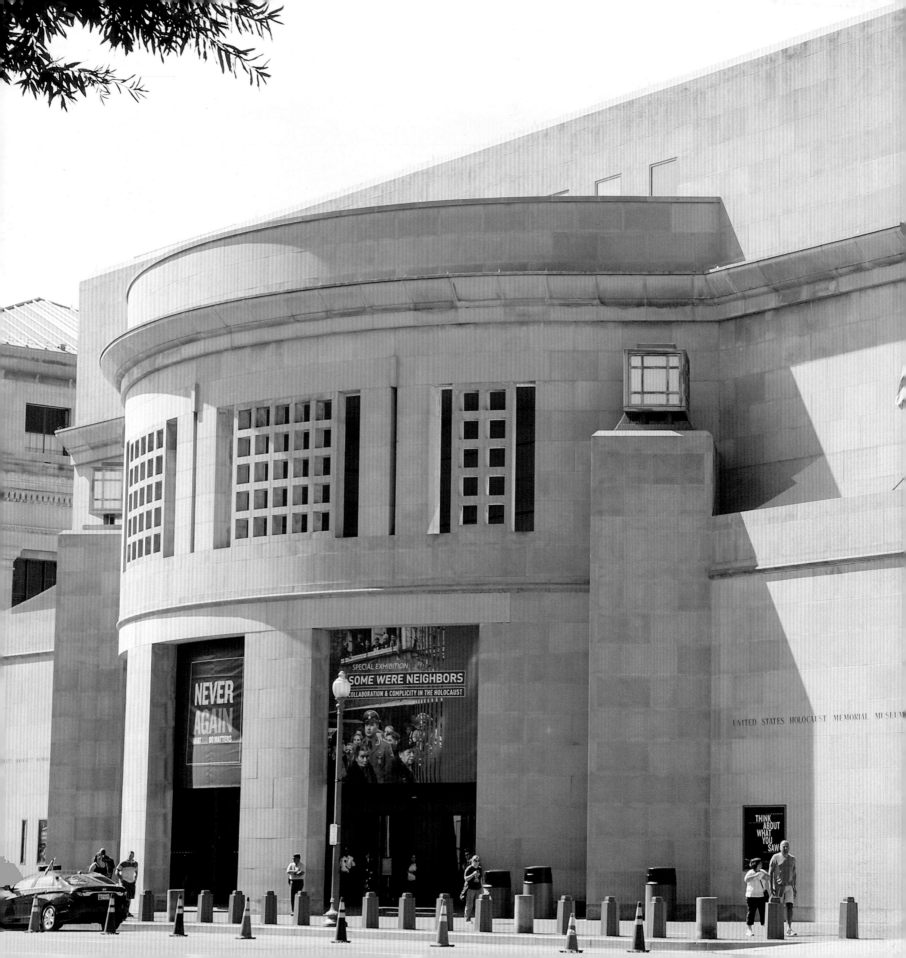

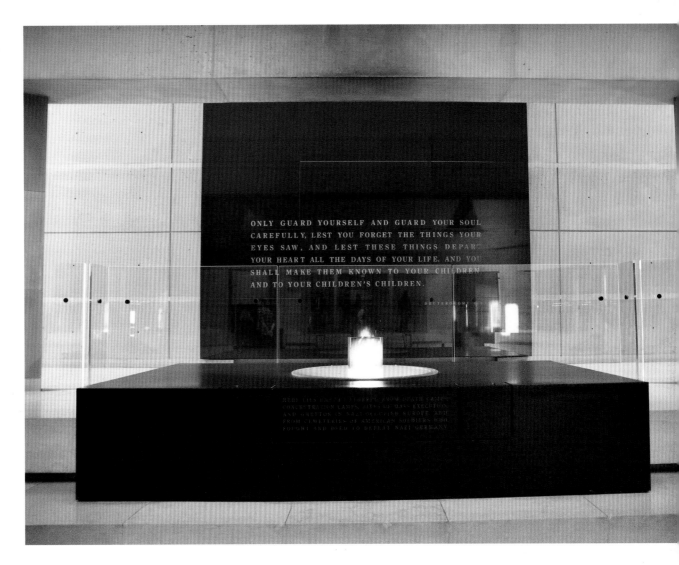

Since its dedication in 1993 the United States Holocaust Memorial Museum has welcomed nearly 30 million visitors. In its mission to "confront hatred, promote human dignity, and prevent genocide," the museum presents artifacts and eyewitness testimonies of the Holocaust. The quotation behind the eternal flame is from Deuteronomy 4:9 "Only guard yourself and guard your soul carefully, lest you forget the things your eyes saw, and lest these things depart your heart all the days of your life, and you shall make them known to your children, and to your children's children."

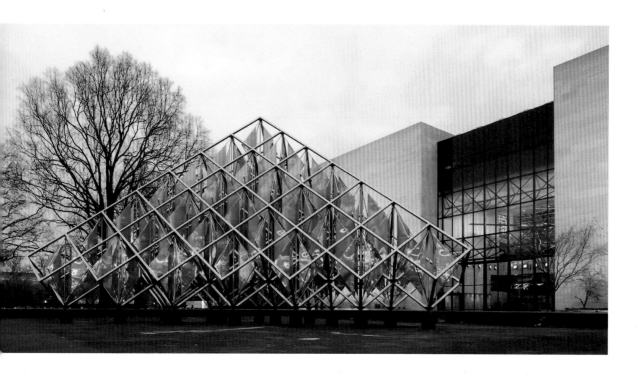

The National Air and Space Museum on the National Mall chronicles the history of flight, from the Wright Brothers to the space shuttle and beyond. With 50,000 historic air and spacecraft, by far the largest collection in the world, the museum can display only a fraction of its holdings. The Steven F. Udvar-Hazy Center (see page 104) provides a second showcase for the collection.

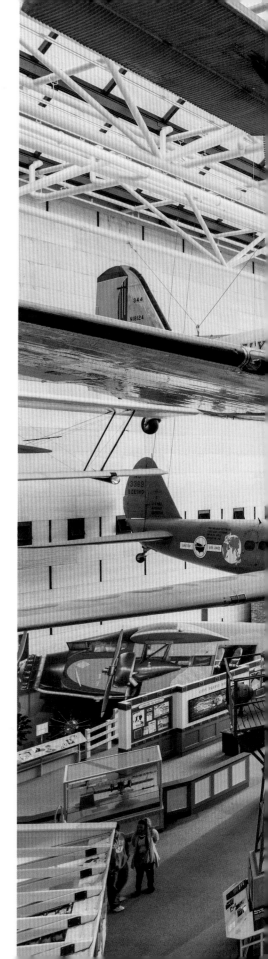

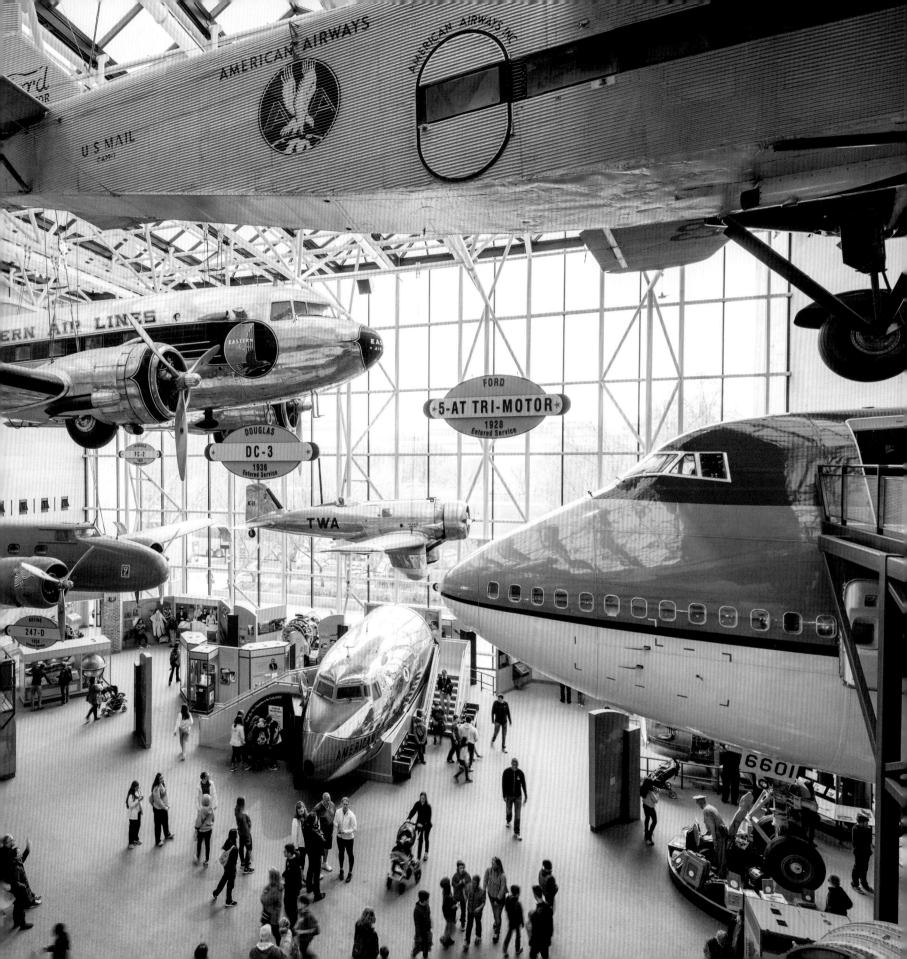

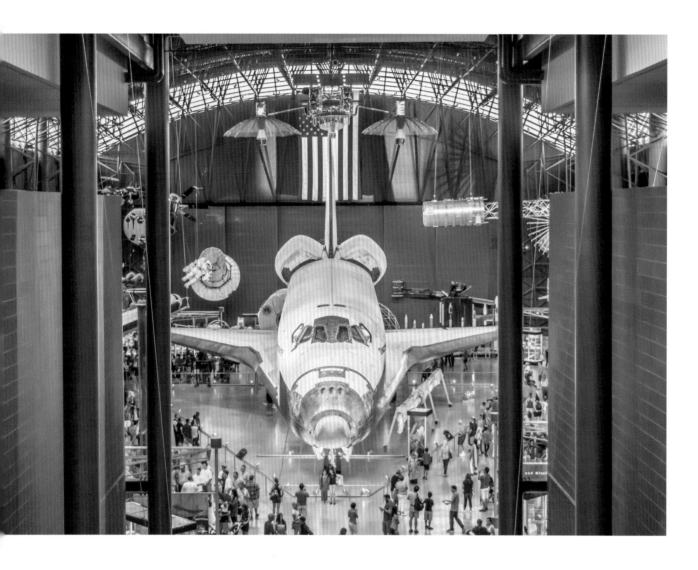

The Steven F. Udvar-Hazy Center, a space pavilion on the grounds of Washington Dulles International Airport in Chantilly, Virginia, contains an outstanding collection of air and space craft. The Space Shuttle Discovery is the centerpiece of the display but airplanes and rockets from every era surround the visitor and provide a complete history of flight and space exploration.

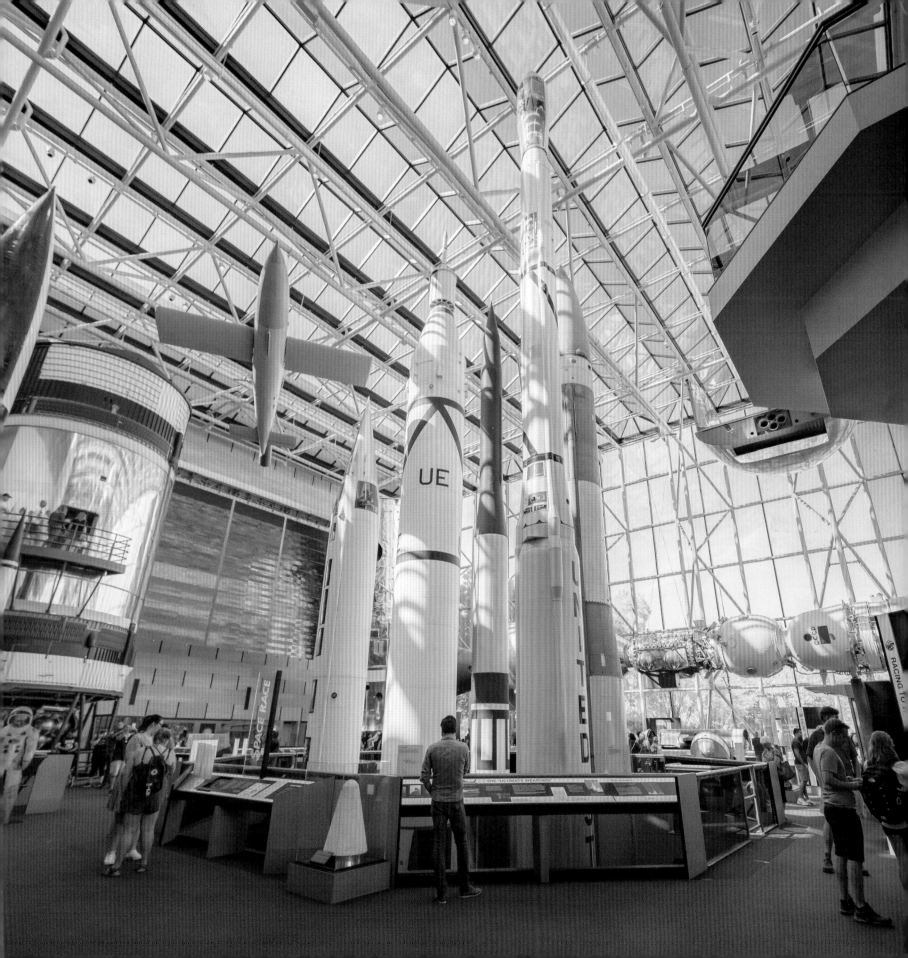

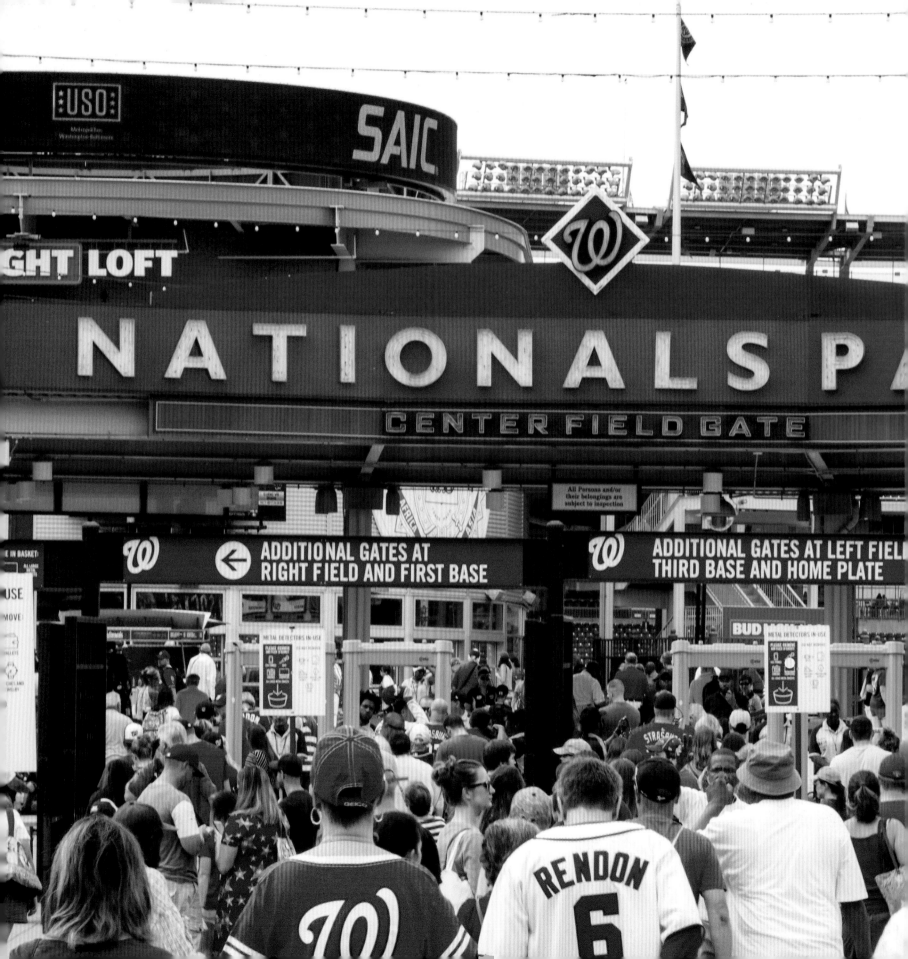

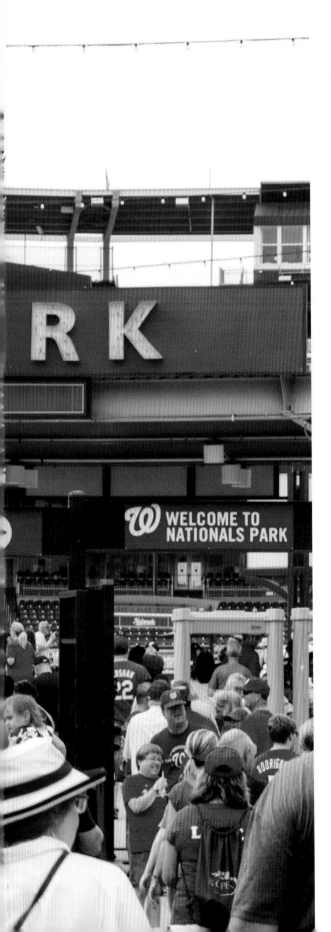

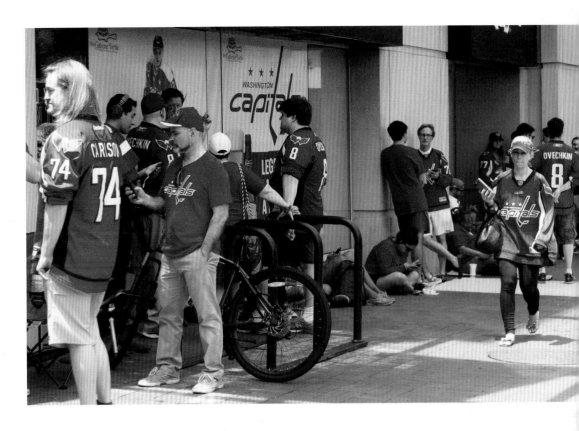

Washington sports fans enjoy supporting the Washington Capitals and the Washington Nationals during home games. The Capitals won the Stanley Cup in 2018. The Nationals won the World Series in 2015.

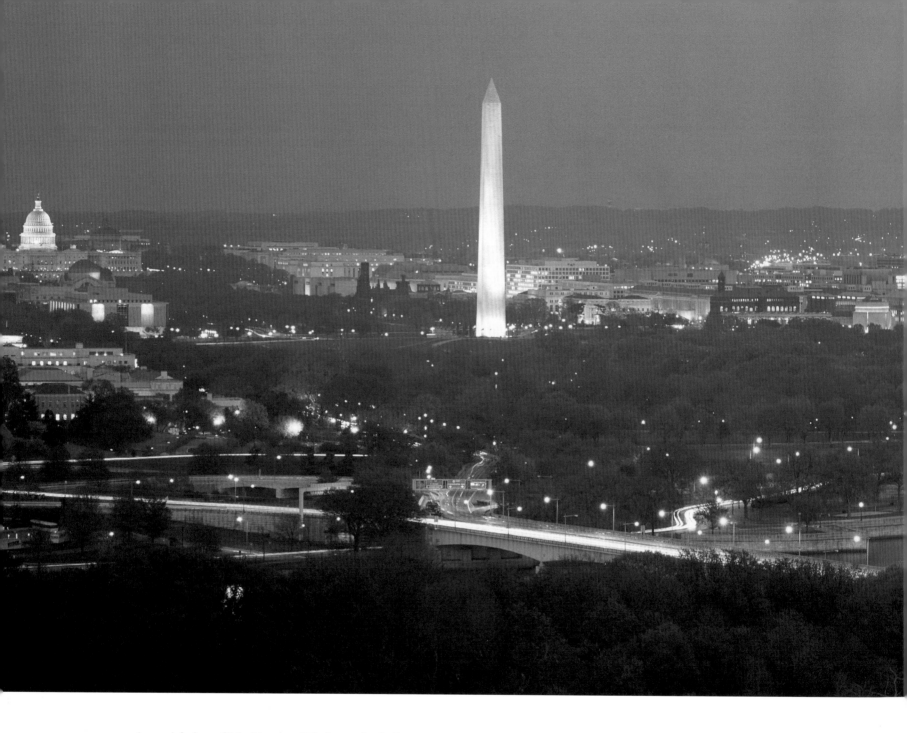

An aerial view of Washington, DC, shows the Jefferson Memorial, the U.S. Capitol, the Washington Monument and the Lincoln Memorial illuminated against the night sky.

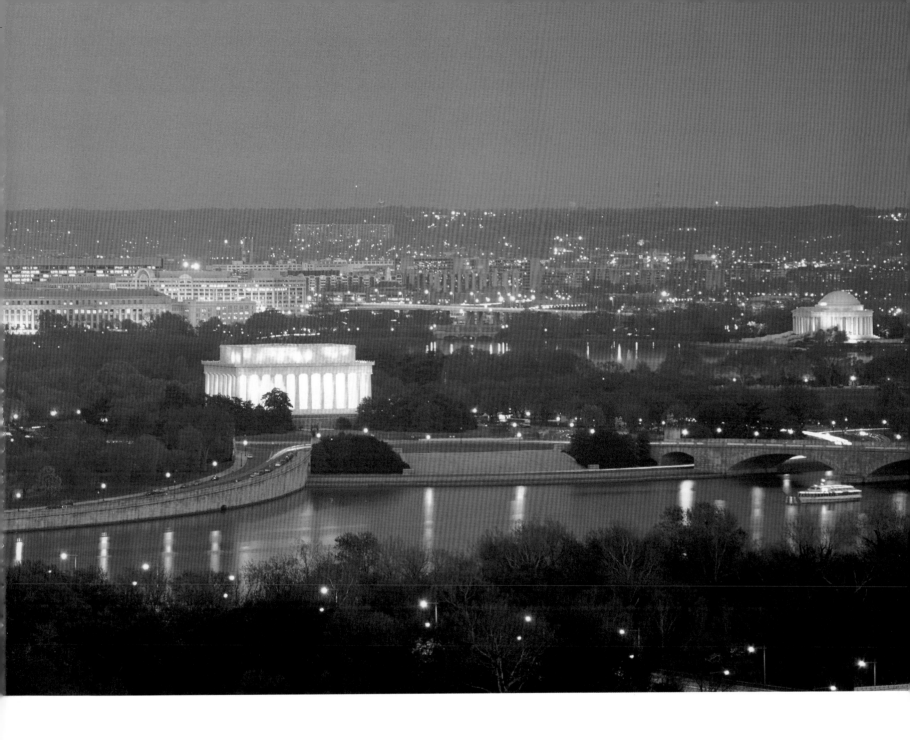

PHOTO CREDITS

ALAMY

Amy Cicconi: 10; APFootage: 34; K. L. Howard: 54; Syed Yaqeen/ZUMA Wire: 56; Nikreates: 68

SHUTTERSTOCK

pablopicasso: cover; Andrea Izzotti: 2; Rainer Lesniewski: 6–7; Sean Pavone: 8–9; Konstantin L: 11; nyker: 12; ieronymos: 13; Orhan Cam: 14; TJ Brown: 15; ItzaVU: 16; DavidNNP: 17; Joe Ravi: 18; Rosemarie Mosteller: 19; Frank Fell Media: 20; Sean Pavone: 21; Tupungato: 22; BLAZE Pro: 23; RozenskiP: 24–25; emkaplin: 26; Truba7113: 27; Adam Parent: 28; Orhan Cam: 29; Sean Pavone: 30; BrianPIrwin: 31; 010110010101101: 32; EQRoy: 33; Noah Sauve: 35; Artem Avetisyan: 36; Roman Babakin: 37; Andrei Medvedev: 38; Anton_Ivanov: 39; Ed Metz: 40; Sean Pavone: 41; Sean Pavone: 42; Alejandro Guzmani: 43; Joe Ravi: 44–45; Andrei Medvedev: 46; cdrin: 47; AHPix: 48; Steve Heap: 49; Andriy Blokhin: 50; Dorti: 51; Joseph Sohm: 52; mervas: 53; EQRoy: 55; Tianyu Han: 57; Victor Maschek: 58; Jeremy R. Smith Sr.: 59; Cvandyke: 60; Sergii Figurnyi: 61; ItzaVU: 62; Adam Parent: 63; 365 Focus Photography: 64; Danita Delimont: 65; Sergii Figurnyi: 66; kan_khampanya: 67; Suzanne Simon: 69; W. Scott McGill: 70; Bill Perry: 71; eurobanks: 72; Tony Quinn: 73; Kristi Blokhin: 74; Kit Leong: 75; Sean Pavone: 76; John M. Chase: 77; Larry Prock: 78; TJ Brown: 79; John S. Quinn: 80; BrianPIrwin: 81; lunamarina: 82; Bill Perry: 83; Foolish Productions: 84; DavidNNP: 85; Nigel Jarvis: 86; Lissandra Melo: 87; Krista Howard: 88; R Doran: 89; Anton_Ivanov: 90; Sean Pavone: 91; Julie Clopper: 92; Andrei Medvedev: 93; Anton_Ivanov: 94; 010110010101101: 95; kan_khampanya: 96; Jon Bilous: 97; Bob Pool: 98; LanaG: 99; Yousif Al Saif: 100; GiuseppeCrimeni: 101; digidreamgrafix: 102; Sean Pavone: 103; Keith J Finks: 104; WoodysPhotos: 105; Jonathan_Densford: 106; Joseph Sohm: 107

INDEX